THE
REALITY
SHOWS

KAREN
FINLEY

FOREWORD BY KATHLEEN HANNA

INTRODUCTION BY ANN PELLEGRINI

**THE
FEMINIST PRESS**
AT THE CITY UNIVERSITY
OF NEW YORK
NEW YORK CITY

-Qaeda executes a series of US suicide attacks: Two planes fly into the World Trade Center in New York,

FOR VIOLET

Published in 2011 by the Feminist Press
at the City University of New York
The Graduate Center
365 Fifth Avenue, Suite 5406
New York, NY 10016

feministpress.org

First printing, March 2011

Cover design by Think Studio NYC, thinkstudionyc.com
Cover photos: top left by Timothy Greenfield-Sanders; top right and
bottom left and right by Max Ruby, SpinCycle
Text design by Drew Stevens
Drawings by Karen Finley

Library of Congress Cataloging-in-Publication Data

Finley, Karen.
 The reality shows / Karen Finley.
 p. cm.
 ISBN 978-1-55861-671-4
 I. Title.
 PS3556.I488R43 2011
 813'.54—dc22
 2010052825

killing nearly 3,000 and injuring over 6,000; a plane crashes into the Pentagon; a fourth plane en rou

CONTENTS

Washington DC crashes into a field in Pennsylvania after being brought down by its passengers and

crew. | **09.13.2001** Osama bin Laden is named as the main suspect in the 9/11 attacks. | **09.18.2001** A series of mailings containing anthrax spores are postmarked and sent to several news media offices. | **10.05.2001** The Georgia Supreme Court becomes the first in the US to ban the electric chair, ruling that electrocution is unconstitutionally cruel and unusual punishment. | **10.07.2001** The United States, with the support of the United Kingdom, makes initial air strikes against Afghanistan. | **10.08.2001** President Bush swears in governor of Pennsylvania Tom Ridge as head of the Department of Homeland Security. | **10.15.2001** The 2001 anthrax attacks continue as a letter containing anthrax is received by the office of Senator Tom Daschle. | **10.23.2001** Apple releases the iPod. | **10.26.2001** The USA Patriot Act is signed into law, expanding powers of law enforcement agencies to search personal records and communications, and to detain and/or deport immigrants suspected of terrorism. The act also expands the definition of terrorism to include "domestic terrorism." | **11.06.2001** In a news conference Bush declares, "You're either with us or against us in the fight against terror." | **11.10.2001** The People's Republic of China is admitted to the World Trade Organization after fifteen years of negotiations. | **11.16.2001** *Harry Potter and the Sorcerer's Stone* debuts in theaters. Christian groups around the country protest the film, claiming the *Harry Potter* series promotes witchcraft. | **11.2001** The US begins broadcasting radio messages into Afghanistan, promising a $25 million reward for information leading to the location or capture of Osama bin Laden. | **12.02.2001** Enron files for Chapter 11 bankruptcy protection. | **12.12.2001** Winona Ryder is arrested for shoplifting at a Saks Fifth Avenue in Beverly Hills. | **12.13.2001** The Pentagon releases a videotape of Osama bin Laden that seems to confirm his role in the attack on the World Trade Center. | **12.13.2001** Bush unilaterally pulls out of the 1972 Anti-Ballistic Missile Treaty, a landmark international arms-limitation agreement. | **12.22.2001** Richard C. Reid is arrested for attempting to ignite explosives in his sneakers while on a flight from Paris to Miami. | **2002** | **01.08.2002** Bush signs into law No Child Left Behind, federal legislation requiring that states wishing to receive federal money for education develop standards-based assessments to be given to all students. No Child Left Behind also requires that secondary schools permit military recruiters the same access to school facilities as university recruiters. | **01.09.2002** The United States Department of Justice announces it will pursue a criminal investigation of Enron. | **01.29.2002** The term "Axis of Evil" is coined by George W. Bush during his State of the Union address to refer to governments h

FOREWORD
KATHLEEN HANNA

I grew up in the suburbs and started smoking pot when I was nine. I was wasted for most of my childhood. I think it was the only way I could deal with watching my dad drink his coffee out of a titty mug every morning as I ate my cereal. (I wish I was joking but he really did have a coffee mug shaped like a woman's breast.)

My nickname back then was "Lil' Goodtimes." I was the tomboy sidekick to my hot older sister whose nickname was, of course, "Goodtimes." It was my job to hold her hair back while she barfed in the skating rink bathroom. But somehow I knew someday things would change for me; I knew I was an artist.

When I was nineteen years old I took a Greyhound bus from Olympia to Seattle to see Karen Finley perform because I read somewhere that she was a feminist. It was 1989. I had just begun to understand the havoc male violence had wreaked on my life. I worked summers as a stripper to pay my way through college, so I felt pretty alienated from the antiporn feminists of the day. I was equally annoyed at the pro-sex feminists who echoed the 1960s "let it all hang out" idea without much analysis of race or class issues.

I was struggling with the fact that I wanted to

be an artist. I wondered if instead it would be more productive to work at the domestic violence shelter. I worried that being an artist was frivolous compared to doing the "real" work of a political activist.

I walked over a mile to get to the venue from the bus station. I had no idea that all my questions were about to be answered.

At the top of her show Karen Finley noticed a man videotaping her and told him to stop. "This is only happening once," she said, and proceeded to challenge the audience/performer divide in a way most punk bands only dream of. She wasn't hostile or mean; she just ripped open the space between herself and everyone in the room and leaped into the most intensely vulnerable, perfectly crafted performance I'd ever seen.

How was she able to stay 100 percent present and also seem to be in a trance? How could she talk about political issues in a way that was funny and tragic, but also make them completely relatable? It was like watching Patti Smith turn into Evel Knievel. I felt I belonged in that audience more than I had ever belonged anywhere.

On the way home I toyed with the idea that doing some kind of feminist performance might be a way I could help other girls feel like they belonged somewhere too. I *could* be an artist and enact my politics.

I bought a file folder, and labeled it "Karen Finley." In it I put every article, review, or notice about her that appeared in magazines like *High Performance* and *Mother Jones*, a cassette tape of her recording "Jump in the River" with Sinead O'Connor, xeroxed pictures of her performing, even her manager's fax number. This was my inspiration.

Within weeks of seeing Karen perform I was in a band writing lyrics about rape. People told me (to my face!) that I was ridiculous and what I was doing was "therapy, not music."

After reading a review of her first book, *Shock Treatment*, I waited anxiously for it to arrive in Olympia's one good bookstore. When it did I realized that reading her writing was just as thrilling as watching her perform. Finally I had found a feminist writer who didn't have to chop herself into bits to be comprehended. Instead she casually blurred the line between the personal and the political and refused to ignore the fact that sexuality is wrapped into everything. And to top it all off, her writing is funny as shit. And I don't mean just ha-ha clever funny, I mean, best friend, middle-of-the-night, pee-in-your-pants funny.

In the nineties my band Bikini Kill began to get national attention, and I was asked to open for Karen when I was touring in New York. I was so fucking excited I spent an entire week memorizing two long pieces so I could "feel the room" like she did when she was performing. I thought, this is going to bring everything full circle for me.

But on the morning of the show I went into a shock-like state. All I could think was, Oh my fucking god, I'm opening for Karen Finley at The Kitchen. I stuttered to my friend that I needed her to call The Kitchen and tell them I was too sick to perform. When I look back on it, I realize this reaction is pretty nuts. I mean, I was already well known, and had played shows all over the world. Why couldn't I do this?

Fifteen years later a friend took me to see Karen's 2009 performance, "Impulse to Suck." And I was

blown away again. Karen Finley can still say more with a weird shoulder move and a sideways smile than most people can convey in a book. That performance is included here in *The Reality Shows*, and it reminds me that it is one thing to see Karen perform, but to read her work lets you get at so many other layers of meaning.

In her writing, pop culture mixes with rage, which mixes with sexuality, feminism, and danger. In the end you have a book that is breathing. Abundant, overboard, too much. Like her performances I can read her books again and again and get something different each time.

After the show my friend went backstage, but I was too nervous and bowed out. I sat outside in the dark for a while and then something crazy happened. Karen Finley walked out into the courtyard and began calling my name. "Kathleen! Kathleen!" I stood up, reached out for her hand, said hello, and acted pretty much like a normal person.

I guess all my nervousness about her has to do with the fact that I can never adequately thank her. I learned what punk really is from her and have emulated her ever since the first time I saw her perform. Karen Finley taught me that art really does matter, and that it truly can change the course of someone's life.

After meeting Karen, I chatted with my friend about how great the show was, walked her to her train, turned the corner, and proceeded to sob all the way home.

INTRODUCTION

The reality shows, but what? And how? After the
US invasion of Iraq, in 2003, Karen Finley returned
to and revised an earlier antiwar piece, "She Loved
Wars." Wavering between first and third person, Fin-
ley teases us with the heat of war:

> Meanwhile, during the [first] Gulf War she glued her-
> self to CNN masturbating. It was a peculiar metaphor
> of glued to the set. A desire where she would press
> her wet cunt to the screen, wrap her legs around the
> TV and orgasm at the Gulf War jingle but I think the
> visual is what counts here.

9

Exactly. The visual *is* what counts here. As with so
many other scenes in the performance pieces gath-
ered in *The Reality Shows*, what Finley gives us to
see— and see anew—is both harrowing and hilarious.
In a double move, Finley takes us from belly laugh to
punch to the stomach, the laughter ripping the stom-
ach open wide enough to let in some unsettling truths:
chief among them, the realization that when war
comes into your living room, shock and pity are not
the only possible nor even the most likely reactions
from viewers whose everyday realities are composed
of mediatized fragments of suffering as spectacle.

aul II writes a letter addressing the issue of pedophilia in the Catholic Church. | **03.24.2002** Halle Berry

Instead, with a beer in one hand and a remote control in the other, viewers can surf from *The Situation Room* to endless repeats of situation comedies, with a quick stopover at the Home Shopping Network, where you can buy buy buy. In a commodity culture dripping with the image, shock and awe are as much a product to be consumed as they are emotional branding devices to get us to put our money down on simultaneously one-of-a-kind and interchangeable must-haves, from Doritos (recall its infamous dog shock collar commercial, which debuted during the 2010 Super Bowl), to Calvin Klein jeans and underwear (behold the young Brooke Shields and the well-packaged Marky Mark), to war itself (cue chants of *USA, USA, USA!*).

I saw and heard Finley perform "She Loved Wars" in autumn 2007, at the Green Room, a downtown performance space in New York City. This short text constituted the first section of a performance triptych "Wake Up!" that also featured "The Dreams of Laura Bush" and "The Passion of Terri Schiavo." "Wake Up!" But, what shall we wake up to? And what bad dreams will trail us into the waking day?

These are the ongoing preoccupations of Finley's work: the way the past haunts the present, our enthrallment to violence, the challenges of healing social and individual bodies, and reforming collectivities. For Finley, these are also feminist questions and feminist challenges, even as her feminism resists easy categorization. It is certainly not "victim art," a tag she and many other socially conscious artists—and especially female artists, queer artists, artists of color—were given amid the culture wars of the 1990s. She was called some other names, too: chocolate-smeared

woman, angry woman, politically correct artist, bitch. "The most popular female may be a victim," as Finley says in "The Passion of Terri Schiavo," as a way of making sense of the national fetishization of Schiavo's comatose form. "We love a female in trouble." But we do not like females who make trouble or who point out trouble. So long as they do not have the audacity to talk back or, ideally, to talk at all, female victims may become icons and heroines. In stark contrast, so-called victim art is pilloried, even legislated against. But all this is a smoke screen, ways of not seeing or of seeing past, the provocations of Finley's feminist visions.

Visions. I use this term deliberately, to capture the way Finley plays in and with the culture of the spectacle, but also to point to the almost oracular quality of her embodied performances, what she brings into view and voice from the past and also conjures for and from the future. To dare to use a still more religious language, I would say that Finley offers a kind of prophetic feminist voice and vision that bends the ordinary rules of linear time.

Feminism is not one; it has never been one. In witnessing to war as a kind of pornutopia, Finley powerfully refuses certain feminist claims, perhaps most famously enunciated in Virginia Woolf's *Three Guineas*, about women's fundamental opposition, as a class, to war. As I have argued elsewhere, the leading role US Secretary of State Condoleezza Rice played in the Iraq debacle, not to mention the past pugilism of other female heads of state, such as Margaret Thatcher and Golda Meir, argues against the sentimental notion that women, "as" women or "as"

11

mothers, would necessarily stand against war. On the contrary, the discomfiting punch line of Finley's "She Loved Wars"—its political recalibration—is that some women may not recoil at war, but might even find the willingness of men to go off to war, to kill and even to die for them, well, kinda sexy.

War makes us hot. It's an unnerving suggestion, and it links up with some other disquieting propositions: men are raised to put their bodies on the line, to die for women and children on the home front. In turn, this manly willingness somehow gives meaning and purpose to a woman's place in the life cycle of war. She has worth, because she is worth killing for, dying for. And so, as Finley chants, "a mother gives birth to another soldier to save her, to protect to save to die for her and the country. . . ." Nonetheless, Finley counsels mothers of the nation, do not confuse this with having the ability to control the terms of your own living and dying. As vessels of life, women are not ceded sovereignty over their own bodies, are not given the power to decide life and death for themselves—a point Finley brings home with devastating clarity in "The Passion of Terri Schiavo."

Schiavo fell into a coma in 1990, the same year that Karen Finley became a household name for improper art and the proper name of a legal case that would reach all the way to the US Supreme Court, in 1998: *NEA et al. v. Finley et al.* The culture wars would find Terri Schiavo, too. She eventually became a household name for female helplessness and the first name of a 2003 Florida state law, Terri's Law, which was written just for her by the Florida legislature amid a national battle over Schiavo's right to die, a right

being exercised for the comatose woman by her husband Michael Schiavo and contested in court by Terri's parents, who could not bear to let their daughter go. Finley does not mock their grief. Indeed, the final passages of the performance piece give elegiac voice to Terri Schiavo's mother as she faces *her* world without Terri. No, what Finley rails against in "The Passion of Terri Schiavo" is the political capture of a woman's life by social conservatives, who basically hijacked the intimate grief of those who knew and loved Terri Schiavo. And all this was aided and abetted by a twenty-four-hour news cycle that loves a good fight—and will kick one up if it comes to it. Terri was the ultimate reality TV show: a projection screen for the fears of dependency, loss, mortality that people cannot bear to face without some mediating scrim.

It seemed an entire nation was on first-name basis with this woman, "Terri," who could no longer speak for herself, her poignant silence filled past the bursting point by the thundering politicians and media pundits who would not let this woman die, but would command her to life beyond life. Terri's role was the perpetual state of being barely alive: not alive but not *not* dead either. As one of the many impassioned I's whom Finley channels in this performance piece puts it, "No one loves Terri like I do. . . . Terri makes me feel alive for she is so dead." Here, love for Terri, like the love for war that Finley explores in "She Loved Wars" and also in "George and Martha," is a love of one's own vitality over and against the death-in-life body of another. In performing our death for us, Terri and the soldier simultaneously hold death at bay and let us see it at a safe remove.

13

Throughout her body of work, Finley challenges us to come closer, to feel the pain—our own—instead of handing it off to another to hold it for us. It seems to me that one of the crucial insights she enables for us is that feeling, or, to use Susan Sontag's language, *regarding* the pain of another cannot simply be a matter of empathetic identification. For one thing, empathy is not always the response to witnessing another's pain or suffering. But, even more fundamentally, we cannot just cross over to the space of another and feel their pain, as the saying goes. To do so is to risk the colonization of the other's feelings; it is also to risk missing the other by mistaking her or him for ourselves.

The question of empathy is at the heart of "Make Love," the evocative piece that opens this collection. As Finley recounts in her introduction to this performance piece, "Make Love" is a direct response to the trauma of 9/11 and to the way New York City came to function in the national imaginary. It was not her first attempt to address these issues, however. She originally created "The Distribution of Empathy," which she debuted at New York City's Cutting Room, in June 2002. As Finley said in an interview at that time, "Distribution" addressed "the politics of emotion, of distributing emotion, and the grandiosity, the depletion—everything that New Yorkers felt after September 11. Besides the horror, there was the emotional burden of either being the victim or having to accept others' love and pity."[†] This was a burden Fin-

14

[†]Dan Bacalzo, "Cutting Edge: Karen Finley deals with the emotional fallout from 9/11/01 in her new performance piece at The Cutting Room," *Theatremania.com* (25 June 2002).

ley willed herself to take on as a performer; but, in her own frank review of "Distribution," she failed, or the piece failed, or the audiences were not yet ready to laugh with tragedy and give free range to their feelings.

Or perhaps "Karen Finley" just got in the way. The audiences could not see past the "Karen Finley" they thought they knew, the one who came neatly packaged like an amicus brief. The "I" of her performance was collapsed into Finley herself, as if the performance were all and only about Finley.

Such charges of "self-indulgence" have been leveled at Finley before—and are routinely leveled at other performance artists who work "solo" and do work that is or appears to be autobiographical. Accusations of "self-indulgence" are deeply gendered, of course. Female artists and queer artists are far more likely to be charged with "narcissism," their narratives read as "simple" or "transparent" confessions that the yawning critic on high has already heard before. But charges of self-indulgence and narcissism are profound misreadings of how an "I" composes itself relationally; *none* of us comes into the world fully formed or solo. The "I" rather leans on others for its origins in another's body, for its ongoing survival, and, if we are lucky, for its flourishing in the world.

Certainly, the "I" of any Karen Finley performance is a deeply considered performance, not some transparent transcription of Finley "herself." More often than not, any Finley performance stages multiple "I's," with Finley their vehicle of expression. Moreover, despite the sense one often has while experiencing a Finley performance live that she is improvising

15

her way through and has no fixed script, in reading the texts in *The Reality Shows*, what becomes clear is the precision of her use of language and the carefully calibrated rhythms of her words. Her riffs—and there is something of jazz in the improvisational feeling of watching and hearing a Finley performance—are anchored in an extraordinary compositional poise.

By Finley's own admission, though, her charged history as a political artist disrupted the careful balancing acts of "The Distribution of Empathy," blocking or thwarting the emotional experience she hoped to generate for her audience. Enter Liza Minnelli. Or, more accurately, "Liza Minnellis," in the plural. Finley-as-Liza, along with an army of other Liza Minnelli impersonators, offered up Liza, a woman with her own outsized, scandal-filled public history, to stand in for New York, New York. Audiences were encouraged to laugh and cry with Liza, rivers of mascara-inked tears rolling down the cheeks to show where the pain had been.

It is a dizzying and delirious performance to witness live, the layers of substitution peeling back like an onion skin. Liza with a Z stands in for New York, New York, and Finley and the other performers stand in for and multiply Liza into "Lizas." It is a performance that explicitly invites projection onto Liza's sequined surface, as this new Lady Liberty says, Give me your fears, your terror, your pain. But these acts of surrogation, in which Finley and the other Liza impersonators take up the burden of pain, are not simple sacrifices. If the audience is invited to project their ugly feelings onto the performers' bodies, it is in the service of getting them to stop dumping their shit

on others. (And war is here imaginable as a dumping unto death.)

Crucially, these acts of surrogation—let me carry your pain—are also acts of love. Finley and her cast of sparkling Lizas are saying, we can hold and bear your pain so that you can come closer, can experience it for yourself, can bear the tension of being alive to loss, alive to the day after 9/11. If only. On September 20, 2001, a scant nine days after the tragedy of 9/11, President George W. Bush addressed Congress and the nation and declared mourning was over:

> My fellow citizens, for the last nine days, the entire world has seen for itself the state of our Union, and it is strong. Tonight we are a country awakened to danger and called to defend freedom. Our grief has turned to anger and anger to resolution. Whether we bring our enemies to justice or bring justice to our enemies, justice will be done.[†]

President Bush's claims that mourning was over were premature, not unlike those he made in his "Mission Accomplished" speech on May 1, 2003, when he declared the end to major combat operations in Iraq.

The denial that our mourning has only just begun and has no set end point is part of what motored the rush to war. Among other things, the Iraq War was a

[†]"A Nation Challenged; President Bush's Address on Terrorism Before a Joint Meeting of Congress," *New York Times* (September 21 2001), B4. See Judith Butler's discussion of this speech in *Precarious Life: The Powers of Mourning and Violence* (New York: Verso, 2004), 29.

way for the United States to act out our losses without knowing their meaning or value, without reckoning with the hard work of mourning, which also requires self-accounting. The losses Americans experienced on 9/11 were not just the people who died or were gravely injured—each of whom is singular and particular to the families and friends who loved that person. Drawing on Sigmund Freud's famous discussion of "Mourning and Melancholia," I would argue that these losses also included, and include, the precious self-images a nation—America the beautiful, self-appointed, shining beacon to the world—has built up of itself, but before which it so often falls short.

This is also one of Finley's main insights and innovations. *The Reality Shows* dramatizes the horrible cost to individuals and societies of casting painful feelings off and onto others. Finley also brings us to see what we do not want to know: the violent, even deadly costs, borne by those onto whom we dump the feelings that we cannot bear to have and to hold for ourselves.

In this collection, "The Passion of Terri Schiavo" directly follows "She Loved Wars." Together they shed startling light on the relationship between the state's right to make war and battles over an individual's right to die. They do so by brilliantly illuminating the dependence of biopower—a term coined by French philosopher Michel Foucault—on the eroticization of war. It's as if Foucault hooked up with Freud, and their queer feminist offspring was Karen Finley. I'm only half joking, which seems utterly in keeping with Finley's own strategic use of humor to do a workaround on the audience's operative assumptions.

Foucault introduces the concept of biopower to make sense of a historical shift in the state's relationship to death in the period we would now call "modernity." Prior to the eighteenth century, he argues, the power of the state, what he also calls sovereign power, made itself known as such by its right to make die, its right that is, to take the lives of its citizens for actual or imagined transgressions against the state. But with changing material conditions—improved health and hygiene, increased food stocks, new knowledge about how disease was passed on and how it could be prevented, and the increased life expectancy and population growth that accompanied these other developments—"life entered history" (Foucault) in a new way, and the state's attention shifted to the question of how best to commandeer and manage life. This new right to make live and to maximize the health of populations, a national body politic, might yet require the sacrifice of individual bodies. When soldiers are sent to war, to kill and risk being killed, paradoxically, they are sent off in the service of life, to guarantee the ongoing life of "their own"—their own families, their own nations.

Another way to put this: the death of some might be justified in service of the lives of many, of the social body. Moreover, this justification might even be conducted through the language of love (as in: we love our country, and that's why we are willing to kill and die for it) and experienced as a kind of erotic thrill (the nearly sexual thrill of triumphing over our enemy, of killing them or seeing their deaths—whether via remote-controlled TV or remote-controlled weaponry). Fighting in the name of one's own, in the name

of love and life, unleashes aggression and violence on a greater and greater scale.

So much of Finley's work, both in *The Reality Shows* and previous collections, such as *Shock Treatment*, is concerned to re-present violence, make us see and feel it differently. If Karen Finley is an exhibitionist—and I think she is, in the best possible way—her point is to expose and exhibit our own enthrallment before the image, to show how spectacles of death and dying so often work to block our ethical vision. Eroticized spectacles of killing and dying are charged with precisely the opposite trend: namely, the task of warding off the specter of our own deaths.

Feminism constitutes one clear intellectual and political anchor for her work. But so too does psychoanalysis. Throughout *The Reality Shows*, her own deep engagement with psychoanalysis, and in particular with Freudian concepts, is both obvious and startling. It is obvious in the frequency with which terms like "projection," "projective identification," "screen," "death instinct," and "trauma" appear. And it is obvious in the playful—and playfully serious—engagement with the dream work in "The Dreams of Laura Bush" or in the racialized oedipal drama she uncovers in her imaginative restaging of former New York Governor Eliot Spitzer's spectacular fall from grace in "Impulse to Suck." (In a denouement Finley would wryly appreciate, the "Lov Gov" has returned from exile to host a point-counterpoint news and opinion show on CNN.)

But Finley's psychoanalytic spin is *startling*, or may be to some readers, in light of the profound sexism of Freudian psychoanalysis and in light, too, of

the accusation sometimes brought against psychoanalysis that it is, at best, apolitical and, at worst, conservative. There are a couple of things to say here. First, to the extent that the language of psychoanalysis is now a shared cultural vocabulary, such that people who have never read a page of Freud can refer to "penis envy" or the "Oedipus complex" without a second thought, Finley is simply speaking a common language. But there is also nothing "simple" about her feminist reuse of psychoanalytic concepts. If you are looking for Freudian or feminist orthodoxy, look somewhere else. Finley, like many other feminists, is picking and choosing from a psychoanalytic tool kit, the better to unravel some of Freud's own assumptions about the meaning of sexual difference. At the same time, it is clear that she also believes that psychoanalysis offers a precious resource for telling, retelling, and making sense of the emotional lives of individuals and whole societies.

And radioactive *half*-lives too. For Finley is interested in how memory and history live on in the present, touching down on and between bodies. Emotions are a form of embodied history. By speaking/performing trauma, Finley insistently bears witness to the ways unprocessed emotions—feelings that are not worked through but are instead pushed off onto others—form and deform public political possibilities.

Trauma is certainly the keyword to the final piece in this collection, "The Jackie Look." It is performed as a lecture on trauma, with Finley—dressed to the nines as Jacqueline Kennedy Onassis—standing at a lectern and imaginatively taking her audience to the Society of Photographic Education in Dallas,

where she/"Jackie" has been invited to give a talk on the activity of "looking at or gazing at trauma." The Society actually exists; its first annual conference was held in 1963, surely not a coincidence, but in Chicago. Dallas, scene of the imagined and performed lecture, is both real and not real: as place and placeholder, the city of Dallas condenses the "real" events of November 22, 1963, as well as their traumatic afterlife in American consciousness.

Finley performed "The Jackie Look" for the first time at the 2009 Society of Photographic Education, which took place in Dallas. I first saw "The Jackie Look" in a workshop version at New York University's Hemispheric Institute. This institutional context brought me to wonder whether she was performing as professor (and Finley is herself a professor at NYU's Tisch School of the Arts), sending up professors, or opening up and questioning the act of professing to the truth more generally. Yes, yes, and yes.

With the events of Dealey Plaza as her backdrop, Finley's Jackie, that professor of traumatology, outlines her lecture. She will go back over her own past traumas with us, sharing photographic mementos of all she had and all she lost, photos that are now also part of the collective memories of American national life: Caroline on her pony; John-John in short pants saluting his father's passing coffin; and, oh, Jackie O, in that blood-stained dress, red-black on pink. But if Jackie walks these fields of trauma with us, for us, she does so for a greater purpose:

> I didn't come here just to reminisce on my accomplishments in grief and styling trauma. I am here to

> consider transformation from trauma and to release
> our national images of trauma.
>
> But how do we do this? How do we honor and never
> forget?
>
> Our nation building is founded on trauma, vio-
> lence, domination, and death.

Finley is here drawing on Freud's classic concep-
tion of trauma as a kind of repetition compulsion in
Beyond the Pleasure Principle (a text from which she
also draws her references to the "death instinct" in
"George and Martha"). The traumatic event we do not
confront, process, come to some understanding of, is
an event we continue to experience—through recur-
ring nightmares, say, or by handing off our unpro-
cessed experience to someone else. Individuals and
whole nations can pass off trauma, and war is one
organized form for this handing off, this passing on.
The traumatic violence is repeated, re-enacted, but
at someone else's address. Think again of President
Bush's rush to close the books on grief and convert the
energy of trauma into the prosecution of war.

The compulsion to repeat an event is due to the fact
that, on some profound level, it was not experienced—
which is to say: understood or comprehended—the
first time round. If traumatic repetition offers a way,
in the present, to experience something that happened
in the past—as if for the very first time—then trauma
warps linear time. The proper sequencing of past and
present, first and second, original and performance,
is called into question. Trauma emerges, then, as a
kind of rupture in time and in history. Something
has happened, but what and to whom and with what
meaning?

23

Finley's genius, a word I do not use lightly, is to bring the charge of performance to the charge of trauma; they meet on the field of repetition. In a famous and field-forming essay on performance, Richard Schechner famously posited, "Performance means: never for the first time. It means: for the second to the nth time. Performance is 'twice-behaved behavior.'"[†] This is so because performance relies on a repertoire of behaviors, symbolic codes, bodily possibilities that precede any given enactment. Social actors—whether on the theatrical stage or in the theater of everyday life—do not invent out of whole cloth but draw on shards of shared memories, possibilities, grids of legibility.

Like performance, trauma is "never for the first time," too. Crucially, trauma is also *ever* for the first time—until such time as "what happened" is given to meaning, folded into the history of our relations with others, of our interdependence with others and with other times. Finley channels Jackie so as to set us— her audience, her students, her traumatized descendants—the following challenge: How do we move forward with the past without remaining in its grip as some sort of recurring nightmare or ongoing destiny? When Finley-as-Jackie offers reminiscences to the audience, this falling back is performed as a way to move forward differently in time, to repeat toward a different future.

"The Jackie Look" suggests that our culture of image and spectacle poses blockages to our ability to bear witness to trauma, where witnessing has the

[†]Richard Schechner, *Between Theater and Anthropology* (Philadelphia: University of Pennsylvania Press, 1985), 36.

sense of grasping and being newly grasped by meaning. And yet despite this piece's focus on looking and gazing (it's called "The Jackie Look," after all), it is ultimately Finley's voice that pierces the air and the ear. In the final section of "The Jackie Look," the little girl voice through which Finley has uncannily resurrected Jackie Kennedy Onassis transforms into a howling moan of protest, grief, accusation. As she talks about her daughter Caroline's abbreviated candidacy for the US Senate seat vacated by Hillary Rodham Clinton and the media's attention to Caroline's habit of sprinkling her speeches with "you know," the "you knows" accumulate fresh force at the level of meaning:

> But her *you knows* have a deeper underlying meaning. This utterance, *you know*, which is associated with an earlier era, a time that defined Caroline. Perhaps she says *you know*, for we do know her, her trauma that informs her service and awareness.

The "you knows" increase in volume, speed, and emotional impact as Finley's Jackie hits a keening pitch:

> But perhaps we need to listen closer, perhaps she is saying YOU NO.
> You, No. You. No. Don't come any closer. Don't take my picture. Don't look at me. Don't come closer. That is why the public pushed her away. She wouldn't be a Kennedy like I was a Kennedy—she wouldn't allow us into the gaze. She won't be her mother. She won't be a Kennedy.

It's a spine-tingling moment that shatters the settled contract through which "we" agree not to see or know what we know.

So much of Finley's work has this quality: a sudden acceleration of emotional pitch and sound, which transcends speech itself to reveal what lies beneath the hum of the everyday. An image floats back in: one of the drawings that illustrate "George & Martha." It's a sketch of the contents of Martha Stewart's consciousness (she's the "Martha" in "George and Martha," natch). The banalities include a gingerbread house, a bunch of tarragon, a carrot with just the right amount of root still attached, a nest of fresh eggs at the ready. These items surround—halo—the words, "I know." This is what Martha Stewart knows as living.

Throughout *The Reality Shows*, Finley asks us, teases us, cajoles us to lean in, listen closer. What will we know or dare? In her stunning use of her body and her voice, and in her nearly shamanistic capacity to conjure other people and other times into fresh life, Finley shows us how deeply, viscerally, emotions matter in public life. In these pages, Karen Finley walks us back through numerous national traumas, a recollection of memory that is also a remaking of the possibilities of collective life.

After all, why settle for making love, when you, I, we can remake it?

Special thanks to Jill Casid for sustaining exchanges and editorial boosts, and to Barbara Browning and Karen Shimakawa, my fab fellow travelers to the wonderful world of Karen Finley.

THE
REALITY
SHOWS

KAREN
FINLEY

ecapitated and his body is frozen in a cryogenics facility, as per a contract produced by his attorney that was

signed on a napkin. | **07.25.2002** Liza Minnelli and David Gest announce plans for the reality show, *Liza and David*, to air on VH1. | **07.28.2002** Nine Pennsylvania miners are rescued after spending more than three days in a flooded mine shaft. | **08.22.2002** The US Foreign Intelligence Surveillance Court rules that Justice and FBI officials supplied erroneous information to receive search warrants and wiretaps. | **09.04.2002** Kelly Clarkson wins the first season of *American Idol*. | **09.06.2002** Congress meets in New York City to honor the victims of the 9/11 attacks. | **09.12.2002** President Bush appears before the United Nations, urging it to join the US in taking action against Saddam Hussein's regime. | **10.09.2002** Aileen Wuornos is executed by lethal injection for the murder of six men. | **10.24.2002** John Allen Muhammad and Lee Boyd Malvo are arrested for the sniper attacks in the DC Metro area that killed ten people and injured three. | **11.14.2002** Democrat Nancy Pelosi is chosen to become the first female Minority Leader of the US House of Representatives. | **11.19.2002** Michael Jackson dangles his infant son over a balcony railing in Berlin, drawing widespread criticism from the media. | **11.25.2002** The Department of Homeland Security is formed. | **11.27.2002** United Nations inspectors conduct the first searches for weapons of mass destruction in Iraq. | **12.24.2002** California housewife Laci Peterson is reported missing by her parents. She is seven months pregnant. | **2003** | 01.22.2003 *Chappelle's Show* debuts on Comedy Central. | **01.28.2003** Bush announces that British intelligence has learned of an Iraqi plan to acquire uranium. | **01.30.2003** Richard C. Reid is sentenced to life in prison for attempting to blow up a plane with explosives hidden in his shoes. | **02.05.2003** Colin Powell reports to the UN that Saddam Hussein is "an imminent threat." | **02.05.2003** Eighteen countries including Italy, Spain, and Poland release a statement of their support for a US plan to invade Iraq. Bush refers to this group as the "coalition of the willing." | **02.11.2003** A satellite called the Wilkinson Microwave Anisotropy Probe produces a detailed map of the universe, confirming the Big Bang Theory and revealing the universe to be 13.7 billion years old. | **02.13.2003** Belgium legalizes same-sex marriage. | **03.15.2003** The World Health Organization issues a health alert, declaring SARS a "worldwide health threat." | **03.17.2003** President Bush gives a televised address, giving Iraqi leader Saddam Hussein forty-eight hours to leave Iraq with his sons. Bush warns Hussein he will face an attack from the US and its allies if he does not retreat. | **03.19.2003** The US launches "Operation Iraqi Freedom." | **04.09.2003** US forces take control of the city of Baghdad, toppling a statue of Saddam Hussein. | **04.16.2003** Bush signs a supplemental budget of $79 billion to help cove

MAKE LOVE

Introduction

On September 13, 2001, I read an article in the New
York Times. *The feature included a photo of* Guernica
*by Picasso. The article was written by several staff arts
writers and was about creating art amid sorrow. I kept
the article with me for a year. On September 13, 2001,
I wrote the poem at the end of this performance. After
9/11, I decided to write about my experience, thinking
of myself as both an artist and a historical recorder: I
was working two blocks away from the World Trade
Center and was on my way to work to read the final
galleys of a book I was editing when the planes hit.*

*Soon after the attack I was struck by the fragmen-
tation, the splitting of personalities, and the projec-
tions of a nation's fears onto New Yorkers. Although
the national tragedy was real and the world was made
uncertain, this national tragedy became a site for the
transference of unresolved childhood losses, fears. The
need people felt to love and give to New York—on top of
their own very real responses to the attack, the death,
the horror—became an emotional overload. And I
apologize, for I feel my language skills are insufficient,*

and my words trivialize an impact that goes beyond words.

I originally created a performance called "The Distribution of Empathy." There was understandably resistance to the performance, to even having it performed or produced. Problems occurred that I believe came out of a psychic avoidance of the topic. Eventually I was able to perform the piece at the Cutting Room on West Twenty-Fourth Street in New York City. The performance was in a cabaret room with a small stage. Food and drinks were served. The chef created the Ground Zero Hero sandwich and other delicacies. I would start the performance by walking through the audience, and they would give their firsthand accounts of witnessing 9/11. I only performed the piece on Tuesdays. Tuesday was still sacred, for 9/11 was on a Tuesday.

Gary Indiana, the writer, told us the story of how his brother was supposed to have been the pilot on the plane that went into the Pentagon. But his brother changed his flight schedule because he had to move that day. For a day, Gary thought his brother was dead. Hearing stories like that in this small, intimate room was profound and cathartic. Usually at the end of one of these performances the audience would be in tears.

On the small stage was a beautiful grand piano. Since my father was a percussionist, and because of my love of pianos, I would not have the piano moved for my performance. I started using the piano in my performance. I changed the performance, and had "The Star Spangled Banner" sung and played. I would at first invite friends to sing; we would rise as an audi-

ence to sing the national anthem. I was aware of the tension, the resistance to standing for the anthem, the political conflict involved in displaying patriotism, the feeling that it was just a performance, and yet the feeling that artists also make up the country.

Eventually I had a singer perform "The Star Spangled Banner," and I decided to refer to music throughout the performance. I noticed my mind clinging to rhyme and music during and following the attack. I recalled that after my father committed suicide, my mother would think in rhyme to ground herself while she was in shock.

I felt people resisting me when I performed the piece. Part of it was not wanting to be reminded about 9/11. But I felt a different resistance, mostly when I was out of the city. I brought the performance to InterAct Theatre Company in Philadelphia. The close proximity of Philadelphia to New York made the piece work. I then brought the performance to Kunsthalle in Bergen, Norway; to New York University; to Hallwalls in Buffalo, New York; to Berkeley Repertory Theatre in California; and to the Big Rodeo Festival in Calgary, Canada.

I felt that the performance was staying on one level: the audience couldn't decide whether or not they felt sorry for me. I really didn't care whether they felt sorry for me—or about the confusion in American politics at the time, the confusion about being an American, or the loaded implication of being against or for the war.

As well, I had to face the fact that Karen Finley got in the way. I realized that as a performer, Karen Finley, my public self or my created self, is viewed as

having a certain sense of justice. This feeling about the character "Karen Finley" can be about someone's personal causes—whether the person is Jesse Helms or a part of the liberal Left. Somehow, in this performance, when I am fragmenting and taking on different emotional levels, some people see it as self-indulgent, as if I were only referring to myself. The audience was not willing to transfer the emotional burden to me as Karen Finley, or share with me.

The title "The Distribution of Empathy" was about a population giving—deciding to give emotionally—as a source of power. The emotional power is schadenfreude, the joy in hearing others' misery. The reverse emotion is envy, which is experiencing pain in the pleasure of others. Both emotions go together. If there is envy present, there is also schadenfreude present. I felt that my performance provoked anxiety, and the audience's resistance to handling these emotions was not breaking through. I decided to use a classic method of displacement. A way to control the fear is to transfer the emotion to an imaginary creature, just as children do to monsters under beds, big bad wolves, or enemies. What was happening emotionally in the performance was avoidance.

I decided to use drag and impersonation. I decided to use Liza Minnelli, a known New York City archetype, a phenomenon. Liza, as an imaginary creature, a goddess, a diva to project onto and live through, to experience through her. Liza, as a parody, as an artistic device to make information less threatening. Drag and being Liza, is a safe, distanced way to experience a too terrifying world, a hatred one wants to avoid. Liza becomes a symbol of a safety zone in between our

dangerous feelings and our neurotic defenses; it saves the audience from feeling a hysterical paralysis.

"Make Love" is a cabaret-driven, lounge-style act that channels Liza Minnelli in song, dance, glamour, and glitter. The "divaness" of Liza, an iconic New Yorker, becomes the place to throw our pathos, hilarity, mockery, taboos about 9/11, and the current chaos of our nation. The unparalleled vicissitudes of Liza's life are the backdrop to witnessing the fascination and revelation of a New Yorker struggling to make sense of it all, or to perform through it all. With piano, torch singing, and myself as narrator, the performance slips in and out of a New York multiple personality disorder (the neurotic tendencies of self-obsession) while trying to process this national tragedy and the current political climate. My reference to Liza Minnelli in the performance is a complex amalgam of pee-in-the-pants humor, pain, and compassionate outpourings of sorrow.

to using faulty Iraq weapons intelligence in their 2002 State of the Union address. | **07.15.2003** *Queer E*

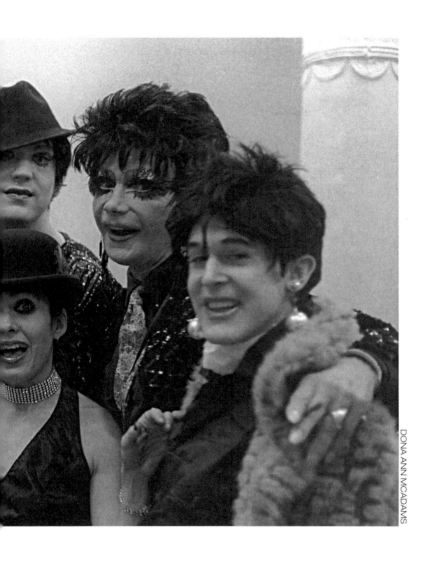

the Straight Guy debuts on the Bravo network. | **07.22.2003** Saddam Hussein's sons, Uday and Qusay

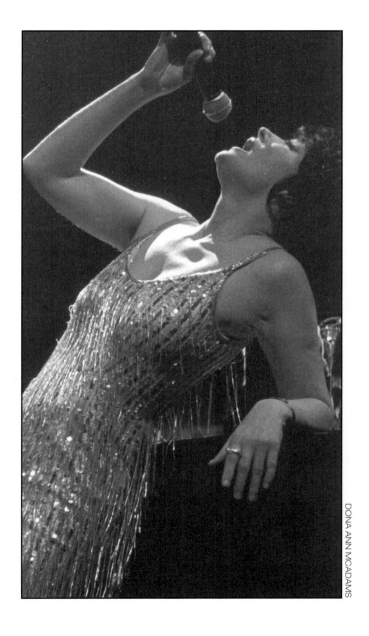

DONA ANN MCADAMS

Hussein, are killed by US military in Iraq. | **08.14.2003** "The Northeast Blackout of 2003" affects the nor

MAKE LOVE

*(The audience is seated in a lounge atmosphere. The
piano player comes out dressed in Bob Mackie drag,
in reference to Liza Minnelli. He plays a medley of
lounge-style tunes that turns into a medley of Ameri-
can war tunes. The singer enters. He is also in sequins-
and-glitter Liza drag. While he sings, the stage fills
with Liza interpreters. Liza is a concept. Liza is a way
of life. Liza is a program. Liza is an emotional process-
ing system for coping. Liza with hip replacement,* Cab-
aret *Liza, child Liza, rehab Liza, sixties Liza. Each
Liza then says her version of:)*

It was such a beautiful day for a tragedy.

*(An interpretation of "On a Clear Day" is sung and
played. The Lizas sit down except for the piano player,
singer, and me, also as Liza. I breathe in and out and
giggle like Liza:)*

Don't you wish for the time when the problem was,
"Who is sucking Clinton's dick!!" Please, someone for
world peace, suck this president! Is there an intern in
the house?!

I would like to start with tonight's specials: Manhattans or Big Apple Martinis. Tonight's appetizer: Dead Man's Fingers in dipping sauce. The fingers are breaded crab claws with a Dijon or horseradish sauce. We have a Ground Zero Hero. I wish it were vegan but it isn't. The hero is cut up nicely for any of you concerned with a mess on your lap. For dessert we have Bombs Away sundaes: blueberries and strawberries over vanilla ice cream.

Emotional Fallout

You are going to die when you are going to die. When it's your time to die it's your turn to die. You could be next. You could be next in line. This was the reassurance I was paying for from my taxi driver. This was the sensitive nuance applied to my approach to La Guardia.

Hello. Hello. Yes, may I have a taxi to the airport? And yes, can you please be sure to send me a driver who will predict my death on the plane? None available? They are all taken? Well, then, I just want a driver who will consider the *possibility* of me crashing.

Yep. It could happen again. My driver instructs me. There is nothing you can do about it if it is your turn to die.

You won't see me going on that plane.

I look out the window. I can't believe I am hearing this. First I stop breathing and then I hyperventilate.

Then I do the reverse routine, which is to make anything into comedy.

I feel if only I can get to Woodstock (*"By the time I get to Woodstock" on the piano, voice going into a trance.*) I can get myself an appointment for a high colonic to relieve the stress of the tragedy and if there are no appointments available I will settle for a wheatgrass enema and if I hurry I will be in time for the organic pumpkins in the open-air market. I have my yoga mat under my arm. The yoga mat is in my uterus. My uterus is my yoga mat. My yoga mat is in my uterus. I have National Public Radio in my pussy. I have Terry Gross in my vulva. I have my sea salt mask scrub exfoliate deep tissue acupuncture chiropractic raw food bar shiatsu massage and a mani pedi and I will buy a selection of Birkenstocks in teal cranberry charcoal and sage and the candles rosemary-thyme-rose-lavender-marigold of aromatherapy will take the edge off . . . NO matter what has happened I am the kind of woman who will bring her hostess a gift—I don't care what tragic event has happened I will bring both a bottle of white and red wine. And we all go to the liquor store to get liquored up. I think this is a good enough reason to drink. I think September 11 is the time to go off the program. Liquor up. All of Manhattan is escaping to the liquor store. And the bottles are placed in silver bags. (*Demonstrate with silver bags so I have a Twin Tower in each hand.*) Everyone in the store holds Twin Towers in their arms. Please take me to Bellevue. Please. I promise I didn't know New York City's water supply reservoir is in Woodstock so the area is surrounded by the National Guard—

39

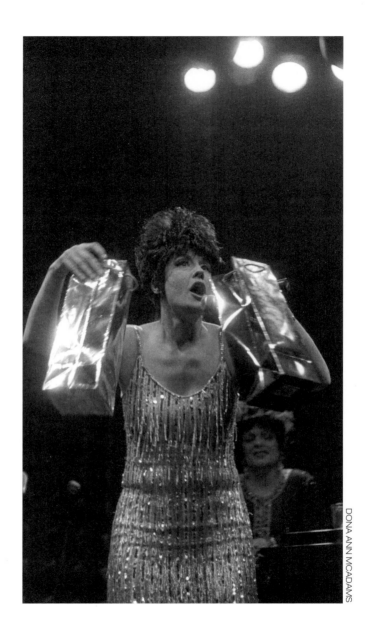

DONA ANN MCADAMS

Bush asks Congress for an additional $87 billion to aid military efforts in Iraq, bringing the total cost of t

from one militarized zone to another militarized zone. Right at home.

I couldn't put the silver Twin Tower replicas on the dinner table of my host and say, "Hi. I know you saw the towers hit but here is a little reminder." I couldn't but David solved the problem and put a toy plane on the two towers.

We spent that night telling Bin Laden jokes. (*Last verse to "Woodstock" sung.*)

I gave cutaway closeup grimaces out the taxi window. I opened my eyes wide, and darted them crosswise. The backseat became an analyst couch the backseat became my lover's bed the backseat became nothing but scents of leather oxblood a giant pair of boots.

If you want to fuck me I need a pair of boots size nine and a leather jacket.

Oh yes, Surrealism came out of World War I. Abstract-Expressionism came out of World War II. Jazz came out of slavery. Butoh came out of Hiroshima. Punk rock came out of someone somewhere hating someone's father.

IT ISN'T "COULD IT HAPPEN AGAIN"—IT IS THAT IT WILL HAPPEN AGAIN. IT IS ONLY WHEN.

The taxi driver swings past the empty airport parking lot. So you REALLY want to go on the plane? There is no one in the parking lot. The only cars left are from

people who aren't alive to claim them. Think about it. I could be the last person you have a meaningful conversation with.

You are so right, Mr. Sensitivity. You are a joy of a human being. Thanks for reminding me that I might crash, that someday I will die, that someday people I love will die—and the only emotion you offer me is to live vicariously through your cruelty? Aggressiveness? Hostility? Which is then my own inverted sadism inverted hostility which is my self-loathing, self-hatred—but let's keep it simple. I want to die. I want to die. Just not now.

LOOK I AM NOT WEARING A SEAT BELT and I take full responsibility just like Princess Di did. Now that was a woman who wanted to die.

42

I was so fucking exhausted that I was not able to overextend and fuse into the taxi driver's life. I had to set boundaries. I had to stay on my resolution from the eleventh of no more living others' lives. I wasn't going to be codependent in the taxi. Live his life be his mother be his confessor be his bank account be his penis be his heart, so instead I decided to intellectualize. Rather, I promised myself that I would intellectualize this moment as soon as I got through security.

Security

In front of me in line waiting to go through security is a woman—let's start this again . . . In line in front of me is a kangaroo and she has boxing gloves on and

she can't get the boxing gloves off to go through security and she is telling her friend, a quagga—What's a quagga?? Let me tell you. A quagga is an extinct zebra-like creature. Like any other decent creative person I had a sideline creative project that was carrying me through this stress, and this project was making a quilt out of extinct creatures painted on handmade paper from Croatia, in a slightly creamy peach color.

Quagga's brother, the Lesser Bilby, an extinct rodent, was to have taken one of the plane bombs, the tragedy plane, but as he was always late he never made it. And now they liked his lateness. And her other friend, a miniature Minotaur, went out of the tower for a smoke just as the plane crashed. So they will never complain about his smoking again; in fact they think it will be a very good idea to start up. There are a few things that have lowered in importance: flossing. Honey, did you floss? No, I am sorry but flossing isn't what it used to be. Honey, I know the air smells like burning Hell but you still have to floss. Another small detail I don't care about anymore is cell phones ringing. Gee, that is a big bad evildoer, those nasty cell phones. So, please, during this show answer your phones. Make a call. Oh, my show is ruined because the phone rang. Arrest that man. The cell phone is disturbing the peace? Bad phone. Bad man. Bad talk.

All of our carry-on is looked through by security. Security. Oh, I can't wait to be searched. I can't wait to be publicly probed for bombs. Searching my skin, the folds of my body, under my breasts, up my thighs.

In my ass. Up my ass. Oh, in my ass. My shit is explosive. My shit is terror. My shit, my bowels are explosions, ready to detonate.

Kangaroo and Quagga had World Trade Center salt and pepper shakers wrapped in newspaper. I overlook and see that the paper is the *New York Times* daily two-page spread of obituaries from the World Trade Center. Kangaroo says to Quagga that the paper will make a nice souvenir. Someday it would be a collectible and worth something. These are not the times to ignore capital gains.

Quagga responds to Kangaroo with:

THE EMOTIONAL AND SPIRITUAL GROWTH POTENTIAL OF THIS ACT OF WAR CAN DO MORE THAN JUST GENERATE EMOTIONAL PROFIT.

Kangaroo knows her friend well and shares this sentiment.

I AM SO GLAD SOMETHING GOOD CAN COME OUT OF THIS TRAGEDY. MAYBE THIS CAN CHANGE THE CITY FOR THE BETTER.

Kangaroo and Quagga were happy with themselves, as if they knew the victims personally and that gave them a feeling of superiority—for they HAD THE SHOW. They were writing the show they were writing the premise they were writing the miniseries they were writing the ad campaign they were writing the in-kind services they were writing the

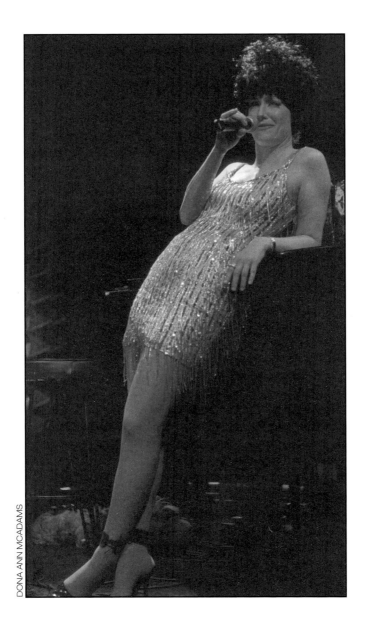

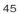

DONA ANN MCADAMS

MD have been found in Iraq. | **10.03.2003** Roy Horn of Siegfried & Roy is attacked by a white tiger and

product endorsement and I decided that the only revenge I could get was to put them in my art later and that is what I am doing now, but somewhere there is resentment somewhere there is the premise that they hold with an emotional investment with this national proclamation of the well intentioned:

THIS HORRIBLE TRAGIC EVENT WILL EVENTUALLY MAKE THINGS BETTER.

Well yes, I had a story too but I wasn't going to use it now for I had promised myself that I would intellectualize the moment.

RATIONALIZATION OF TRAGEDY EXTENDS AND FURTHERS GRIEF IN ITS PATHETIC ATTEMPT TO ASSUME CONTROL WITH UNCONTROLLABLE IDEAS.

We are entering the plane now and hold on to our fear the fear is here a smile make the smile a smile make the grin make the teeth make I look and I know I look New York look at me I am New York don't look at me you don't want to look at New York ok look I am seething at your remarks when really I know that you are just trying to come to terms with why you never came to New York to make it, that you never took the risk, the plunge, and it doesn't even have to be New York it can be the New York metaphor the dream that goes hand in hand with being part of New York living in New York is a character trait, a state of mind, a neurotic tendency an archetype all its own. And I know how humble and modest you are and how family-orientated, that you know God better than me, made the

better decisions than me. I am your anxiety . . . and the destruction and lives lost in the Big Apple become a trigger point for some people who were never able to try out their dreams, do what they wanted with their talents, make their dreams happen. The dream factor is also the fear factor. When the Big Apple falls we feel assured that we made the right decision in not doing that with our lives for that was the fear all along.

I had peace of mind for a moment and enjoyed my self-righteousness that I had made sense out of tragedy and maybe my higher education was worth something after all.

I wished I could be like other people and feel comfortable in jeans.

Walking onto the plane I see Kangaroo and Quagga. They are holding a baby. And I realize I have this all wrong. Kanga and Quagga are a lesbian couple who were in New York at our fertility clinics. I was ready to live their life that they hadn't lived anyway for I could live their life be their life in a way that wasn't their life. Kanga has the baby and Quagga is smiling at baby and the plane is überbabywelt. Baby rests on Kanga's shoulder. Baby is the baby of a Muslim woman passenger. She is traditionally dressed in a burqa. She has two babies. One must be just over a year and the other is a newborn. Kanga and Quagga are helping the Muslim woman get to her seat, a mother, another mother. The stewardesses are in a panic, they don't even notice that she doesn't have a

car seat for either of the babies. The passengers watch when Kanga hands the mother her baby. Kangaroo turns to Quagga and says—joking as if she is telling her favorite Bin Laden lightbulb joke—

"YES, I WAS CARRYING THE BABY AND THE BOX-CUTTERS ARE IN THE DIAPERS!"

I am now seated in the same row as the Muslim mother and her babies. She doesn't look at me.

"Did you bring a car seat for the baby?" the steward-ess asks. "You won't be able to fly with both babies in your lap. You are going to have to get off the flight."

May I take care of your baby, I ask? So I sit next to her and hold her newborn. I put my hand in the diaper bag and everyone looks and sighs with relief when my hand returns with a bottle and not a bomb, a genie, a country, a plane, hatred. I give the baby a bottle, pat and rock the baby to sleep as the mother tells me she already misses her home in New York City.

Everyone tries not to stare out at the skyline but instead looks ahead.

A moment where everyone was trying to remember a missing address, a missing parent's face, the hand of your first love. Trying to see the towers in the sky like on a rerun of *Friends* like on a rerun of *The Nanny* like on the bus like eleven like twins like Popsicles like two fingers like two legs.

man, porn star Marey Carey, *Hustler* founder Larry Flynt, and pundit Arianna Huffington. | **10.21.2003** Dav

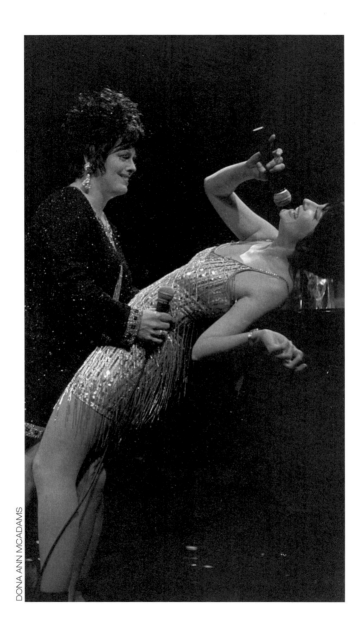

DONA ANN MCADAMS

Gest sues Liza Minnelli for $10 million claiming that she frequently beat him during their sixteen-month mar-

I hold the baby close and look out at the heavens.

(*To the music of "On a Jet Plane"*)

And think
Someone's baby
Everyone's child
I looked out to the heavens
I looked out into blue
Oh blue
How blue oh true blue
Oh spacious skies
Oh baby oh baby blue

(*An interpretation of "On a Jet Plane" played and sung*)

So when you call me and tell me I should be so grateful to God should go pray to God get on my knees get on my knees be thankful to God for I know you know God better than me, you are closer to God than me, live a life that God approves of more than me, have better values than me. And your pity and charity and kindness are disguised envy, your disguised bitterness, but I just take it.

Just take it. For we are New Yorkers. We know OUR job. We know OUR role. We don't have time for this rural, small-time, petty bullshit. You are still telling me to pray. I should pray for my life for my brother-in-law's life who worked in the World Trade Center that I wasn't walking past at that moment that I didn't know that I was safe my daughter was safe and

I burst into tears
For it was someone's daughter someone's brother—
Someone's sister
Someone's mother
Someone's father
Someone's child
Someone's baby
Everyone's child.

The Discovery in the Safety of the Past

When I looked up at the fire the plane the explosion I
saw my father's red head of hair with blood gushing
out of his brain I saw I saw the suicide bomber as my
father the suicide bomber at that moment looking up
we still at first thought it was an accident that is what
they call suicide at first at first at first we thought it
was all an accident so I looked up and saw my father's
brain and felt felt and felt.

When I looked up I saw my father's head exploding.

When I heard the tower fall I heard my father's body
slam against the cold cement. When I heard the tower
fall I felt my heart leave my body as we ran as we ran
that was easy that was easy and peaceful for I have
been running my whole life, running my whole life
from the fear with the fear.

The real true fear after the attack is repressed fear,
personal private fear emotionally reawakened or gen-
erational emotional fear legacies finally manifested in
this horror. In our expressed collective grief we can

51

Robinson becomes the Episcopal Church's first openly gay bishop. I **11.13.2003** Alabama chief justice Roy S.

now without guilt express our own personal childhood terrors of abandonment and abuse in the safety of disguise known as national mourning.

As the people ran past me running for their lives for the first time I felt peace I felt my internal fear for my life my internal panic now externalized and from then on everyone looked how I have always felt.

And as I stood in Lower Manhattan with the thousands of us running and even if coming here was against our will America was built and grows from fear. And it is the strength of our people in overcoming all of our obstacles that we are strong, through trials and tribulations, through drought, thick and thin, through the kicked out and in we have seen fear in our hearts on our backs fear in our face fear in our homes fear in our bodies fear stories told to us from boats in chains, from tenements, plantations and ragged feet, from the back of the bus to the end of the line to the changing of the names to no need to apply.

Our projections as a nation of living with fear. Our leaders. Our fears heightened with national security so we are in national bondage, our country is a national S&M torture chamber. The heightened alerts—THE HIGH ALERTS. Our president only feels potent when he is on the brink of killing—the tension of the violence—the fear I recognize THE FEAR I SMELL AND RECALL THE FEAR OF BEING KID-NAPPED AND TORTURED THE FEAR OF BEING ON THE BRINK OF DEATH AND EROTICIZED BY MY KID-NAPPER THE FEAR I FELT AS YOU WERE ABOUT

TO PUT THE GUN TO MY HEAD THE KNIFE TO MY
EYE AND I SEE THE LOOK ON YOUR FACE I KNOW
THAT FACE I KNOW THE DELIGHT IN RUMSFELD
TOO WELL I KNOW THE LOOK OF TOO HAPPY TOO
COCKY OUR LEADERS SEE THE COUNTRY AS THE
WET PUSSY READY TO CLAMP DOWN CHAIN CHAIN
CHENEY DICK CHENEY . . . AND LOSE IDENTITY
I SEE THE SEXUAL TRINITY OF BUSH COLIN AND
DICK DICK DICK CHAINNNNEY CHANEY WITH THE
GIN MILL OF RUM RUM RUM RUMSFELD—ABOUT TO
PISTOL-WHIP ME FOR THEY NEED THE FEAR TO GET
IT UP—SO HAPPY IN A UNIFORM BUSH'S MOTHER
HE WAS TOLD WAS THE FATHER OF THE COUNTRY—
BARBARA IS THE FATHER OF THE COUNTRY AND HE
WAS NEVER GOOD ENOUGH—HUMILIATED NEVER
GOOD ENOUGH TO BE A BUSH ONLY C-MINUS BUSH
HATES AMERICA FOR HIS MOTHER IS AMERICA HIS
MOTHER IS THE FATHER OF THE COUNTRY HE IS
GOING TO DESTROY THIS COUNTRY THAT TOOK
AWAY HIS FATHER LOVE FROM HIM HE IS GOING TO
DESTROY THIS COUNTRY BY HAVING THE WAR BY
BEING A GOOD DRY DRUNK AND PUT US IN INTER-
NATIONAL DEBT LIKE ALL GOOD ALCOHOLICS DO
FOR THE COUNTRY AND LIKE ALL GOOD ADDICTS
DO THEY LOVE TO FIGHT THEY LOVE A GOOD
DRUNKEN DISORDERLY FIGHT AND THEY TAKE IT
OUT ON THEIR FAMILY HIS FAMILY HE TAKES IT OUT
ON HIS NEIGHBORS AND HATES HIMSELF SO MUCH
HE IS THE EVILDOER WHEN BUSH TALKS ABOUT
SADDAM HE IS TALKING ABOUT HIMSELF SADDAM
HUSSEIN IS HIS SHADOW SADDAM HUSSEIN IS
HIM HE IS THE MAN WITH THE WEAPONS OF MASS
DESTRUCTION WHO IS OUT OF CONTROL HURTING

54

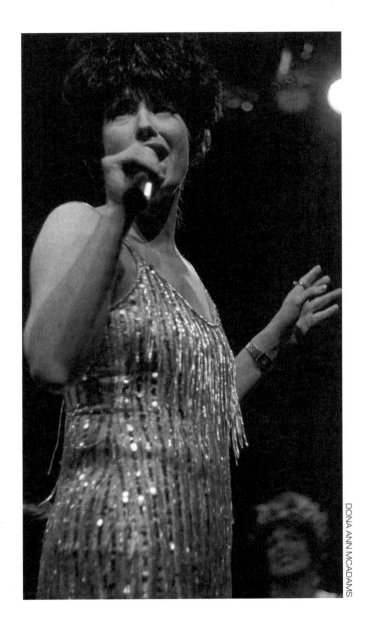

DONA ANN MCADAMS

rules anti-same-sex marriage laws unconstitutional in Massachusetts. | **12.13.2003** Saddam Hussein is found

HIS OWN PEOPLE IN ORDER TO FEEL POTENT HAS
TO BE ON THE BRINK OF WAR IT'S HIS CRACK IT'S
HIS HIGH GETTING UP EVERY MORNING TO GET HIS
FIX OF GOING INTO THE BAD NEIGHBORHOOD OF
THE SOUTH BRONX WITH BROTHER COLIN POWELL
AND IT MUST FEEL GOOD GETTING HIGH PRESI-
DENT AND CONDOLEEZZA—HE WISHES HE WAS IN
THE AFTER-HOURS BAR SITTING WITH HIM WATCH-
ING GET SO EXCITED IN THE TAVERN TOOTING IN
THE BATHROOM WATCHING GUNSMOKE—WHY
DOESN'T HE COME OUT AND JOIN THE EULENSPIE-
GEL SOCIETY—THE OLD EUROPE—YES FRANCE
AND GERMANY KNOW—THIS IS AN ISSUE THAT CAN
BE SOLVED WITH A STRAP-ON—BUSH CAN'T WAIT
TO BE SURROUNDED BY MEN IN UNIFORMS DYING
FOR HIM—HE CAN'T WAIT FOR POOR WHITES AND
STRAPPING BLACK MEN DYING FOR HIM DYING FOR
THE COUNTRY AND REMEMBER HIS MOTHER IS THE
FATHER OF THE COUNTRY.

All of New York had become nice overnight or over-
day. It was terrifically inconvenient and terrifying
and not good for sales. I was in the Midwest and was
doing my best to wait for the concierge—well that is
my word—and so I tried politely, waiting as if I am
from Wisconsin, or Michigan, somewhere on a Great
Lake, waiting. I am dressed in ice-blue leather pants
with an iridescent trim with a matching not exact
mind you jacket with poodle collar cuffs and a shiny
mirrored bag with the crotch open with little clitorises
made by NYPD from World Trade Center rubble and a
patch worn on my cunt that reads

HOT PUSSY ON FIRE—NYFD—

And I am spoken to, "Nice pants—where did you get them?"

Not here in this cow town in this sage-green Birkenstock town of no shaving NO I DO NOT want to come to your home for dinner NO I DO NOT want to be your friend.

No, in New York we do not JUST DROP BY WE DO NOT JUST go over to each other's homes and visit—we do not just drop by—we don't hang out—we do not JUST hang out in New York—no, I don't want to know you no I don't want to be your friend.

Hello, can you please help me? I am in a state of terror in high alert—I am in the state of mid-America can you please—now I have an idea for you—want to help—want to help out New York? Can't make it over don't know what to do—start being New York. That's right—take off the mauve. Take off the beige take off the last year, the flannel—shave—we don't do sweatpants.

Can you please get me a room now and save me a *New York Times* instead of *USA Today*? (*to the music, "These Are a Few of My Favorite Things"*) *USA Today* is not a paper!! *USA Today* is not a paper. You call this service? Towels more towels more call waiting and two lines and a fax. No I am not here for pleasure. No I don't want to see your town no I don't want to see where you live no I don't need to see it for myself I would not be here for pleasure no I do not want to see

your two-block art neighborhood will you get off of the phone and get me my key get me a real newspaper you call this a headline you call this a newspaper? You call this journalism? You call this an arts section? You call this art? You call this fashion? You call this looking good? You call this fun? You call this crowded? You call this an opening? You call this culture? You call this taste? You call this busy? I am relaxed. This is relaxed. This is not aggressive. This is not aggressive. What do you mean you don't serve after 9:00 p.m.?— what do you mean the town is closed after 9:00 and on Monday? You call this a cup of coffee? You call this a piece of pizza? You call this theater? You call this a haircut? You call this service? What do you mean I can't get a taxi? What do you mean I can't get a drink? You call this a college town? You call this a university town? You call this civilization? You call this a town? How can you live here?

57

(Singer and piano: Interpretation of "These Little Town Blues.")

I went to my room and there was an email from a journalist from the *Wall Street Journal* wanting to interview me about the drama—the art direction of the World Trade Center attack compared to the art direction of the attack on the Pentagon.

He had read my article for the *Village Voice*—"Straight Woman's Guide to Gay Male Sex"—and he thought I would be a good person to talk to.

What was I to say?

Because there were two?

It was bigger?

It was higher in the sky?

Since Abbie Hoffman tried to levitate the Pentagon . . .

No. I did not ask to have the article sent to me when it came out. I get another call on my other line, my friend talking about anthrax at Rockefeller Center.

Hello, yes, just a minute—I am talking to my friend about her antibiotic prescription and then oh, yes I did get your email about the dramatic art direction of the crash. Why don't you talk to Eric Bogosian he saw the whole thing from his window, I talked to him all about it or, or better, Richard Serra. (*Addresses audience*) I felt that sculptors weren't given enough opportunity in the press.

I paused and for a moment I felt detachment, and that this conversation would be appreciated at the next Whitney Biennial.

I look out the window and on the marquee of the state theater where I was to perform was: Now playing: Karen Finley and *Apocalypse Now*.

Distribution of Empathy

("Strange Fruit" on blues piano:)

TELL ME TELL ME TELL ME YOU ARE ALRIGHT
TELL ME TELL ME TELL ME YOU ARE ALRIGHT
TELL ME THAT EVERYONE YOU KNOW IS SAFE
TELL ME YOU WILL TAKE CARE OF HER

My body has three thousand people dusted on me and
we smell their bodies burning and I pray when I take
a shower and I pray when I wash my hands for their
body is burned on us burned burned dusted dusted
and somewhere there is god and someone is god and
and and
And some trees bare a strange fruit.
Blood on the leaves
Blood on the root
Scent of magnolia sweet and fresh
Sudden smell of burning flesh

and people are running like the world has ended but
there is love in ways that you will never know there
was love and concern in a way that I have only read
about and it is such a beautiful day it was such a
beautiful day.

And yes we want to die that is the point but just not
now and the women are wearing bikinis urging the
men on and on and on and all the men are running
to help and all the restaurants stay open and all the
trucks send cell batteries send boots and for days all
of the sweats all of our men all of the women helping

59

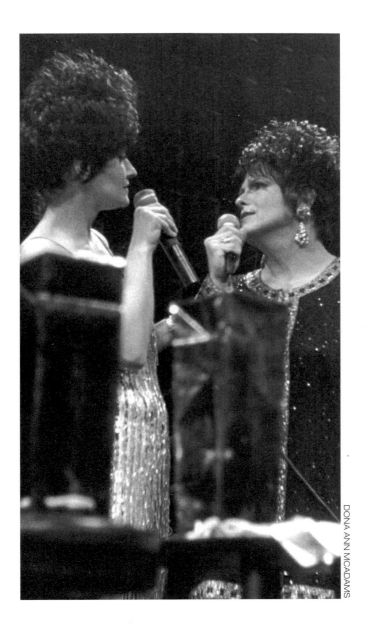

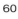

DONA ANN MCADAMS

O'Neill appears on *60 Minutes* and reveals that the Bush administration had been planning an attack against Ir

Dan Rather is crying and we are eleven crying all the time and we are all having fucking terrorist sex fucking terrorist sex fucking—I just want to fuck your face away—I just want to fuck your memory away—I just want to fuck the pain away—I just want to fuck the fear away—I just want to fuck the suffering away—I just want to fuck the burning away—I just want to fuck the hate away—and we all take lovers and we all all all want the desire the sex the heat passion fuckhot heat want no name no name sex fuck we all know someone know someone and we all have a story and we all live on the island and we all love god—your body goes down the drain—and I can't wait to go to the club the after-hours club called Ground Zero and I am fucking firemen and policemen SAVE ME SAVE ME in the caverns and there are seven floors below and there are subways and there is liquor and the days and nights are warm and we all love each other and we women come down to do our share of healing our men and whisper in the ears fantasies of times before this before this:

Silk moist panties (*to "Is That All There Is?"*)
Fan on my wet spot
And blow the taste
Of semen, sweet grass and gone bad love
Everything smells like fucking
Oh, sweet sweet fucking

Get me in that subway
Heat, flesh
Bodies so close like orgy

Get me in that elevator
Alone, stranger
See I'm not wearing panties

Get me on the veranda
So I can get a closer look at you
Pulling on what makes you a man

With windows wide open
I hear your moans and play with myself
Till we come at the same time.

Please can you kiss? Please can you kiss each other?
Sometimes all you can do is kiss. (*I ask the audience to kiss. We stop and watch audience members kiss. The Lizas start kissing and hugging the audience.*)

Liza? Do you kiss? (*I say it to the singer*)

Singer, Liza #1: He said the only time I have sex with you is when I hate myself.

Karen, Liza #3: And so you responded like any well-adjusted adult with

My place or yours? Let's get this relationship over with before it even starts.

(*I speak to the piano player:*) Liza, do you kiss?

Piano Player, Liza #2: Well you know what they say, you better have fun now for you'll be dead for a long, long time.

Karen, Liza #3: There are two kinds of people.

Singer, Liza #1: Size queens.

Piano player, Liza #2: And liars.

I had done all the shopping I could for my country and thought maybe I should read what I was working on on September 11.

(*I lean on the piano in a suggestive backbend, flicking my tongue while speaking over the music.*)

Insert

"Why can't you get married so we can have an affair like other people?" She laughed with her head held back arched and she tilted her pelvis with her pubic bone down like she was pressing on his circumcision. He knew what she was doing and he grabbed her mane from behind so her throat now swan stretched his mouth sunk in swimming with swan neck as one. He couldn't stand it when she mocked him. He pressed his face to hers to hear her breathing her breath that he loved to hear her heart race her blood pump her face in painful pleasure as her panties stretched and pulled her youthful femininity. His hands grabbed her inner leather her eyes rolling back as he pressed himself more into her. She was panting out of breath as he satisfied her.

"I don't know why you won't even give me an A?" She gasped as if this was the time to ask while he looked at his desire's eye just before he was to come.

He responded with, "The answer to 'what style of painting is Monet's *Water Lillies*?' is not SCRAWLED OVER MULTIPLE CHOICE WITH—TEACHER I WANT TO SUCK YOUR COCK!"

Her eyes rolled back in place and she stopped seeing double.

"I certainly gave you an IMPRESSION!" She laughed so uncontrollably that her eyes began to tear. She was mocking him again. She knew how to get to him. How to pull the trigger. Reel him in. Work him.

He pulled her face firmly toward him as he held his cock for her to take.

Her hair was in her mouth tangled from the laughing and she pulled the strands of tightly wrapped hairs around her tongue as she interrupted the passionate moment with her girlish glee she looked out of the classroom past the chalkboard, the smell of erasers, and empty desks.

In her outtake gesture the hair wrapped in her mouth loosened from her tongue and fell down her throat and caused her to choke.

(Singer, Liza #1, grabs me and pumps me)

Karen, Liza #3: WHY DON'T YOU GO FUCK YOUR-SELF?

Singer, Liza #1: That's what I'm trying to do!

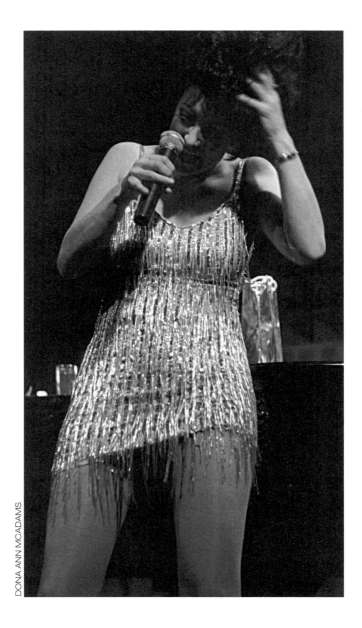

DONA ANN MCADAMS

yor Gavin Newsom orders the San Francisco City Clerk to begin issuing marriage licenses to same-sex

And then a series of decisions quick and deliberate external and internal events occurred in a rapid pace.

As our student was gasping for air you would presume he would help her in her struggle. But remember what turned him on was the sound of her breath as she orgasmed. In an instance he wanted to give her a pleasure of that intensity to release her choking membrane but within an instant he withdrew from her and pushed his engorged instrument full force again into her pussy. He made five knockout punches into her inner cavity and then came.

Came together.

While she came everything became clear for up to this point she thought she was teacher's pet because of her personality, her charm, and originality. She would always remember that he didn't let her die. He had enough practice, control to stop his torture in just enough time. He cleared her throat and even got her a glass of water. (*I whisper in singer, Liza #1's ear to say the following line:*)

Singer, Liza #1: How does it feel to have your pussy turned into a cunt?

She was economical in her response for she already knew that her creative, witty reply would not be appreciated. But she couldn't resist it and said it for herself.

"Why don't you bring in the principal for sloppy seconds." She looked up at him.

(*I whisper a line in Liza's ear*)

Singer, Liza #1: Hey don't look at me like that . . . it gives me a boner. She knew it was getting dangerous. So it was time to bring out the vacant look.

(*Give a blank stare, a stupid look*)

He noticed her blank stare and wanted to fuck her again.

But the bell rang.

Class was over.

I am on the plane from Australia and I see the Canadian passport. I think, Oh no, I will have seventeen hours of explaining American foreign policy. Yes he is Canadian but he is also Palestinian and I do listen to his views about American foreign policy. After a few hours I take his hand and say I am sorry, it is a long flight. He then breaks down crying desperate and says, "You don't understand I am Palestinian but my wife is Jewish and that makes my children Jewish. You don't understand. You must help. You must help."

I am on the plane from Los Angeles and I sit next to a woman who is emigrating from Vietnam. Her fiancé's father is an American soldier, his mother Vietnamese. He was orphaned during the war. She is so happy

and loves America. She tells me that I probably know where she is from. Her family lived near the My Lai Massacre. I look at her in horror and tell her I am sorry. I am so sorry. And then I order us both a glass of California chardonnay.

I am on the plane and I get every book I can on the Middle East. I have books on Arafat. I realize that the couple seated next to me are survivors of the Holocaust returning to Israel. I decide to put my books under the seat.

I sit next to a music teacher from Bedford Stuyvesant High School. As we fly over New York he sings "New York, New York" and he points out the Empire State Building, the Chrysler Building, the Brooklyn Bridge, and we see the lights from the World Trade Center. Then he looks down and says there is Union Square and then I remember.

As I run down Broadway through Tribeca I run and run till I reach Fourteenth Street and think I am at a safe enough distance to take the subway. I walk down the stairs to the 6 train in front of Virgin Records. And the subway is closed. All subways are closed. I am standing on the stairs and an old man stands in shock.

He is in distress. He keeps saying what should I do? What should I do? He tells me that he works at a construction site in Brooklyn—the site overlooks Manhattan right over the Brooklyn Bridge. His daughter worked in the World Trade Center and he saw the

plane hit the tower he saw the plane hit the tower and he tried to jump too. He didn't know if he should go to Harlem, go to the hospital, go to the World Trade Center. I couldn't stay for I had a daughter to go to.

Do we need to make the story sadder? How close were you? How close were you?

(On the table I overturn the silver bags so they are two towers. An orange light projects the shadow of the towers.)

Our Unbearable Grief Our Unbearable Sorrow

Give us a sign so we can lessen the sorrow
Lessen the nausea that overwhelms our belly

Give us a sign
So I can bring my lips to a smile
To taste the wine of indulgence once again

Given a sunny day
The day too beautiful, the day too blue
No storms of ice no cold
To make escape for some possible
Let me appreciate this with some form of grace

For I never want to leave her running again
Our city of bridges and tunnels
City of millions
I never told you how I love your multicolored braids
and curls

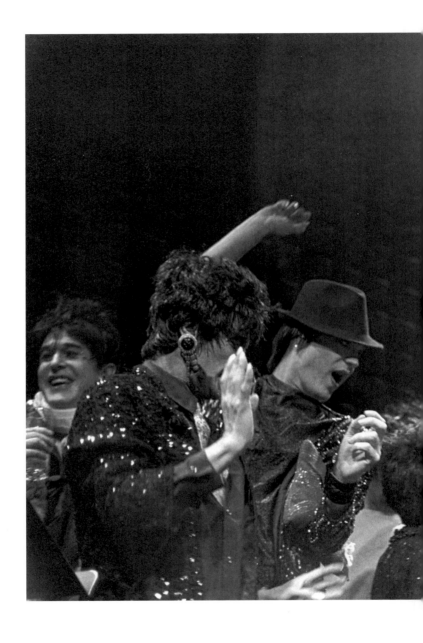

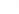
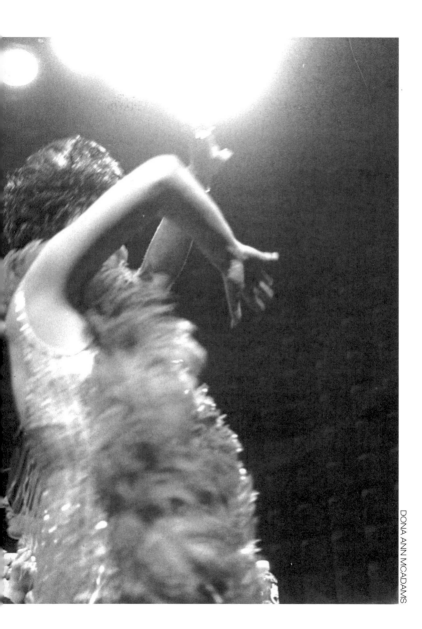

DONA ANN MCADAMS

dence that Mars once contained a life-sustaining liquid. | **03.11.2004** The California Supreme Court orders

Your dancing eyes up all night partying
Your heart of music and poetry
Your mind for business schemes and the mob

Oh, we all love her
From the rich and the desperate
To the middle of the road
She was arrogant and proud
In reminding us
That we were in a city
That was not afraid to do what you were born to do

I confess
That in this sunny day I do not see mercy
I confess
That in this explosion of destruction
I do not see a creative new day

Give me now the strength to see the love of man
Give me now the act of faith to carry on
So that the next generation can have one less sleep-
less night

Give me now the act of hope
To look at you and say
Yes, there is a future in this nightmare
For you to be able to come to the city of dreams

I know this dancing lady offends many
She talks loud, buys expensive things and is
Such a know-it-all
But when the party is over
And if she is not there
There is no party

So as I learned from the Irish
As we drink at our wake of the dead
Please keep the Apple in your eyes
By toasting her today
Buy something outlandish
Speak out of turn
Respect your privacy
Make and enjoy money
Love art
Love the finest of everything

But remember this is hard for her
She is not used to being comforted
Take her hand and comfort her
She will let you comfort her
I will let you comfort me
And I will try not to cry too long
I promise
As two hands clasped together
Were found from two persons
Clasped together
Held together
Giving comfort.

Epilogue

Last night I dreamed that a huge skyscraper crashed
and collapsed. It was filled with artists and art from
all continents from all cultures from all over the world.
It was a UN of creativity of expression. Every artist
was given a plot to create a work of art on. Now, I
associate and I see that every artist was given a grave
to create a work of art on. Then the building came

tumbling down and that skyscraper was you. That
skyscraper was you.

Somewhere here is a message
Somewhere here is a metaphor
Somewhere here is a cosmic web that makes sense of
a terrible time.

I stay up nights contemplating this
But nothing ever comes of it.

(*Music from "On a Jet Plane." Fade.*)

Credits

Karen Finley: Liza #3
Chris Tanner: Singer, Liza #1
Lance Cruce: Pianist, Liza #2

Other Lizas (from the performance at Joe's Pub, New York):

Dirty Martini: Palladium Liza
Miss Webb: Cabaret Liza
Matt Mohr: Rehab Liza
Flawless Sabrina: What-the-Fuck Liza
Robert Appleton: Living-the-Legend-Most Liza
Gary Hayes: Hip Replacement Liza
Brandon Olsen: Tall Cabaret Liza
Taylor Mac: Kidney Dialysis Liza
Violet Overn: Mini Liza
Sacha Yannow: The Real Thing Liza
Helen: Abandoned Liza
Pamela Booker: Rasta Liza
Bina Sharif: Muslim Liza
Steven Menedez: Leather Daddy Liza
Philip Trevino: Better-Late-Than-Never Liza

a "child in utero" (defined as a human fetus at any stage of development in the womb) legal rights if injured or killed. | **04.06.2004** Former *American Idol* hopeful William Hung releases his debut album, *Inspiration*, which features his infamous version of "She Bangs" by Ricky Martin. | **04.08.2004** Bush allows Condoleezza Rice to testify before the 9/11 Commission. Under oath, Rice covers up key information about security and intelligence leading up to the 9/11 attacks. | **04.10.2004** Following Condoleezza Rice's testimony before the 9/11 Commission, the Bush Administration releases the president's daily briefing from August 6, 2001, entitled "Bin Laden Determined to Attack Inside the United States." The report states that members of al-Qaeda had been in the US for several years and were thought to have been conducting surveillance of federal buildings in New York. | **04.15.2004** In a broadcast of an audio tape, a man believed to be Osama bin Laden offers a "truce" to European countries if they do not attack Muslim countries. | **04.25.2004** An estimated 1.15 million participants rally in Washington, DC to protest the Bush administration's "shadow war" against reproductive rights in the March for Women's Lives. | **04.28.2004** Photographs surface of prisoner abuse by US soldiers at Abu Ghraib prison. | **05.07.2004** Morgan Spurlock's documentary film *Super Size Me*, which explores the effects of a McDonald's diet, opens in theaters. | **05.17.2004** The first legal same-sex marriage in the United States occurs in Massachusetts. | **05.19.2004** Tony Blair is hit with a purple flour bomb in the chamber of the House of Commons during a session of Prime Minister's Questions. | **05.2004** Martha Stewart proposes community service, specifically teaching "the art and science of cleaning" to underprivileged women, as an alternative to jail time. | **06.05.2004** Ronald Reagan, the fortieth president of the US, dies at the age of ninety-three. | **06.15.2004** *1 Night in Paris*, a sex tape starring heiress Paris Hilton, is released. | **06.25.2004** *Fahrenheit 9/11*, Michael Moore's documentary on the events following 9/11, opens in theaters. | **07.04.2004** The rebuilding of Ground Zero begins as the cornerstone of the Freedom Tower is put into place. | **07.06.2004** Massachusetts senator and Democratic presidential hopeful John Kerry picks North Carolina senator John Edwards as his running mate for the 2004 election. | **07.16.2004** Martha Stewart receives a five-month jail sentence for insider trading. Shortly after, she gives an interview to Barbara Walters and says, "I could do it. I am a really good camper. I can sleep on the ground. Many good people have gone to prison. Look at Nelson Mandela." | **07.25.2004** Teresa Heinz Kerry, wife of presidential candidate John Kerry, tells a reporter to "shove it." | **07.29.2004** John Kerry accepts the Democratic nomination for president. | **08.03.2004** The Statue of Liber

SHE LOVED WARS

Introduction

With George Bush's invasion of Iraq in 2003—initiated under the delusional reasoning of weapons of mass destruction—I revived an earlier text to protest war.

SHE LOVED WARS

She loved wars. And Kosovo was no exception. She thought it had to do with the fact that she was conceived during the Korean War during battle as her father lay wounded, cut up, as the story goes, and her mother a nurse listened intently and complied to his last dying wish to have one last fuck.

Well, that's the romantic version.

While having sex with her sitting on him the bed collapsed, or a bomb hit but that's the morning after version of his demise.

So the offspring couldn't wait to get to any war anywhere for her entire adult life.

Meanwhile, during the Gulf War she glued herself to CNN masturbating. It was a peculiar metaphor of glued to the TV set. A desire to press her wet cunt to the screen, wrap her legs around the TV and orgasm at the Gulf War jingle, but I think the visual is what counts here.

After that she took to picking up Vietnam War vets begging for money on street corners with signs on rotting cardboard with markers and spit that read IF NOTHING ELSE SMILE, their legs sewn up with sweaters that were last used in kitty litter pans. She found that the simple straightforward approach worked the best—want a quarter and a beer?

She did have her boundaries set on character traits in her own unique way. And she reasoned the particulars with: it was her own life and she'd do what she damned pleased. Odd days—no beard. Even days—beard.

I suppose I forgot to tell you that this was an everyday occurrence. She'd roll down the window of her Jetta and strain her voice over the song "War"–want a quarter and a beer? It would always work. She'd bring the soldier, captain, grunt over to her place and turn on *Apocalypse Now*, *The Deer Hunter*, *Platoon* and watch the grunt's reaction that was so very dear to her. Her first line of questioning would be, So which film gets you going more: *The Deer Hunter* or *Apocalypse Now*? And the vet would say, When Christopher Walken puts the gun up to his head I'm a fucking goner. Usually there wasn't much sex but plenty of beer. But still when she had a gimp in her presence she could never turn down the opportunity to massage the stump, lick the stump. And then pose and suggestively say to the vet, "I want you to stump me." Yeah, there isn't anything like being stumped by a vet with a man attached to it.

The vets liked her and once it was said to her, I had a
good time with you even though you are a civilian.

She loved to hear a vet reminisce.

I didn't want to go to war. Tried everything. Cutting
off my big toe. Gaining fifty pounds. Telling them I
was a queer. Should have just went to Canada. Loved
a girl there though. Loved a beautiful Vietnamese
girl. And she was blown up in my face. I loved her.
We couldn't talk. But who the hell needed to talk.
We just loved. Ever just love someone? Ever just love
someone? There is no issue of future. No issue of com-
munication. No issue of families. Just love. Pure and
simple. So that is what the war taught me. Love. I
see so many men. Working, working. But not loving.
80 A man is raised to die. A man is raised that his body
isn't for life it's for death. For protecting. In all cul-
tures the man is to be prepared to die. Give his life if
necessary.

Because the dynamics was fatherly familiar, you'd
think she'd call them daddy. No, she called them
pappy. The time was never anything that was
planned or calculated like a specific fetish or S&M
session. It was just a room for her to feel a man's
pain of being raised to die. That's it—that was the
turn-on for her, that men, boys are essentially raised
to be worthless. Their lives, nothing, meaningless.
That they can, will die for their country, their fam-
ily, their wife, their children, their flag. And yet they
walk around like they own the goddamn world—but
any day the draft, the war—and any day another

man makes a war with other men, so more men can die for another man's country, to save the country, and a mother gives birth to another soldier to save her, to protect to save to die for her and the country for god another bullet to take.

This was the intention, the truth behind her act her fascination.

And it turned her on to no end. For here she felt all-powerful where her femaleness, womanness had made some goddamn common sense. And that she was with men who would die for her. She was with a man who would die for her. She was worth dying for. She was worth dying for.

people protest the Republican National Convention in New York City. The NYPD responds by carrying out mass arrests using large orange nets. | **09.13.2004** Colin Powell testifies before the Senate Governmental Affairs Committee and acknowledges that the sources of his 2003 report to the UN were wrong. | **09.18.2004** Britney Spears marries backup dancer Kevin Federline. | **09.21.2004** Yusuf Islam (formerly Cat Stevens) is placed on the No Fly List and is unable to enter the United States. | **10.06.2004** A final report by chief UN weapons inspector Charles Duelfer concludes that Iraq "essentially destroyed" all illicit weapons by the end of 1991. | **10.08.2004** Martha Stewart enters a minimum security prison in West Virginia. She says she will miss her pets but hopes to be released in time for her spring gardening. | **10.10.2004** Christopher Reeve, best known for playing Superman, dies at the age of fifty-two. | **10.29.2004** Al Jazeera broadcasts excerpts of a videotape of Osama bin Laden claiming responsibility for the 9/11 attacks. | **11.02.2004** George W. Bush is elected for a second term. | **11.12.2004** Scott Peterson is found guilty of the murder of his pregnant wife Laci. | **11.15.2004** Colin Powell announces his resignation. | **11.16.2004** Bush nominates Condoleezza Rice to replace Colin Powell as Secretary of State. | **11.30.2004** After seventy-four consecutive wins on *Jeopardy*, Ken Jennings loses his seventy-fifth game and ends his record-breaking winning streak. | **12.01.2004** Longtime television anchor Tom Brokaw retires. | **12.08.2004** At a town hall meeting in Kuwait, Secretary of Defense Donald Rumsfeld is questioned by a solider about the lack of protective equipment for the soldiers and their vehicles. Rumsfeld has no immediate answer. | **12.14.2004** French president Jacques Chirac inaugurates the world's highest bridge, the Millau Viaduct, a thousand-foot high cable-stayed bridge that spans 1.5 miles across the Tarn valley in southern France. | **12.26.2004** An earthquake triggers a devastating tsunami in the Indian Ocean. | **12.2004** UGG boots and Kabala bracelets are named as some of the year's most notable fashion trends. | **2005** | **01.12.2005** The White House announces the end of the search for WMDs in Iraq. | **01.20.2005** George W. Bush is inaugurated for his second term as forty-third president of the United States. | **01.26.2005** The Senate confirms Condoleezza Rice to become the first female African American Secretary of State. | **02.10.2005** North Korea formally announces its possession of nuclear weapons. | **02.14.2005** YouTube goes online. | **03.04.2005** Martha Stewart is released from prison. | **03.16.2005** Robert Blake is found not guilty of the murder of wife Bonnie Lee Bakley. | **03.17.2005** Ten Major League Baseball players appear before the House Government Reform Committee to answe

THE PASSION OF TERRI SCHIAVO

Introduction

Do you believe in the right to die? Under what circumstances would you want to be kept alive? Would you want your parents to intervene/interfere with your spouse's right to act on your behalf? Do you feel a society should keep someone alive whose brain is not *functioning? Does society have an obligation to keep a body alive when the brain is dead? Should that care be required for someone in a persistent vegetative state, no matter what? At any cost? Do you feel that the president, the Supreme Court, and Congress should be able to intervene in such decisions and go against an individual's stated wishes? Who pays for this care? Who is denied care? Should a brain-dead person who can only be on life support with no hope of consciousness be given special consideration over healthy people who do not receive care?*

On March 31, 2005, Terri Schiavo died of dehydration in Florida. Her feeding tube was removed thirteen days earlier. This one woman's unfortunate series of events goes back over fifteen years, involving courtroom drama, Governor Jeb Bush, President George W.

Bush, the entire US Congress, celebrities such as Mel Gibson, religious leaders such as Jesse Jackson, and even the pope.

Here is a brief summary and timeline of the Terri Schiavo case: In 1990, Ms. Schiavo collapsed in her home. She was twenty-six years old. She had been suffering from bulimia, an eating disorder that involves binge eating and self-inflicted throwing up. She was also being treated with drugs for infertility. It is widely known that bulimia can cause disruption in fertility. At the time of her collapse she had a significantly lowered potassium level, which is also consistent with bulimia. A drop in potassium can cause a heart attack. It did.

After Terri's heart attack, she fell into a coma. Michael Schiavo, Terri's husband, took over guardianship of his wife without any objection from her parents. Michael Schiavo sued the fertility doctors and won a malpractice settlement in 1992. In 1993, Terri's parents sued to have Michael Schiavo removed as guardian. They were concerned about the quality of her care. The courts could not find any wrongdoing, but Terri was appointed a second guardian by the court, who concluded that Terri was in a persistent vegetative state with no chance of recovery. Michael decided to take Terri off life support, stating that Terri had said in earlier, healthy years that she would rather die than live hooked up to machines. The court-appointed co-guardian noted, though, that Michael Schiavo could have a conflict of interest in wanting to remove her life support.

In 2000, a judge agreed with Michael's request to have Terri's feeding tube removed. Since there was no

written document of Terri's wishes, Michael and other witnesses gave testimony that she said she would not want to be kept alive under such circumstances.

In April 2001, Terri's feeding tube was removed for the first time. It was reinserted two days later after her parents, the Schindlers, filed an emergency motion based on new evidence indicating that Michael Schiavo lied about Terri's wishes. Although the judge dismissed the motion as untimely, the Schindlers filed a civil suit claiming Michael Schiavo lied about Terri's opposition to life support. Pending this new civil trial, the circuit court judge ordered the reinsertion of Terri's tube.

For the next two years, the Schindlers and Michael Schiavo were in legal battles in the District Court of Appeals in Florida. Various methods were used to try to assess Terri's condition, including mediation. A new team of five doctors, two from each side, and one court-appointed doctor, examined Terri. Appeals and new claims were brought by each side. The court mandated that the feeding tube should be removed, prompting Terri's parents to file a new motion to keep it in.

In 2003, the Florida State Supreme Court refused to review the case that the district court had ruled on. On October 15 the district court decided that Terri's tube could be removed. The Schindlers filed a federal lawsuit in response. Governor Jeb Bush rushed in to support the Schindlers, and filed a federal court brief. The Florida House of Representatives enacted Terri's Law, a one-time governor intervention. The tube was reinserted. The case went back and forth between parents and husband, and between public figures and private

citizens, until the tube was removed for the last time in March 2005.

I am interested in the tremendous, fever-pitched emotion and the political, ethical, and moral dilemmas the Schiavo case posed. It became an extraordinarily heated exchange of energy, a life force of its own. I consider the passion to be especially interesting—so many people suddenly concerned with this individual's right to live at a time when so many other people were dying. It struck me that people did not consider the lives lost during wartime with the same passion they had to save Terri.

At the writing of this essay, the US has lost over one thousand, seven hundred soldiers in the Iraq War. Over forty-two thousand Americans have been maimed

86

as a result of war. Over one hundred and eleven thousand Iraqis have died. There are daily suicide bombings. Why is the war—the killings in Iraq—not given the same focus that Terri Schiavo inspired? Why did George W. Bush become so involved with this particular case, wanting to keep Terri alive, when as governor of Texas he regularly signed off on state-sanctioned executions, killing more death row inmates than were killed in any other state? And what is it about this culture that makes us fixate on women in crisis?

America has a history of focusing on women in crisis, on women who have been victimized. Recently there has been a spate of female victim narratives in the national media: Nicole Simpson, Laci Peterson, Chandra Levy, Terri Schiavo, and Natalee Holloway. Why are we drawn to this ongoing serial of whodunit? Why does the culture legitimize heroic victimization?

I believe the sensation of this national conversation creates intimacy. The daily infatuation, the desire to know, to be close to the source—this keeps us together. With television as our reality, as reality TV becomes fiction, and fiction becomes reality simultaneously, our boundaries of self and our individual rights become blurred. We suffer from a national character disorder in a cultural arena of dichotomies. The Schiavo split functions for American society in the same way that multiple personalities serve a purpose—as a way to cope with trauma. Indeed Terri has served as a national pastime to mirror a psychotic culture, divided between parent and spouse, child and adult, Florida and Pennsylvania.

Although there are thousands of individuals who are not kept on life support every year, Terri Schiavo became a place for us to transfer an uneasy, confused state. The debate brought us together as a nation. Because without Terri, there is no side; there is nowhere to place our feelings. We feel more secure being on any one side of an issue.

Terri is us—we who are collapsed, who have eating disorders, who have heart attacks, whose hearts are not functioning, not feeling. We who have fertility problems, who haven't taken care of ourselves, who don't take care of the sick, and the dying, and the dead. Terri continues to be us when she isn't responding, she cannot see, she is completely dependent on the state. That sounds like America to me.

87

ll dies. | **04.09.2005** Prince Charles marries longtime lover, Camilla Parker Bowles. | **04.19.2005** Joseph Rat

THE PASSION OF TERRI SCHIAVO

1

No one loves Terri like I do. No one loves Terri like I do. I can feel Terri. I have spoken with Terri. Terri and I communicate in a way I communicate with no one else. Terri makes me feel alive for she is so dead.

Don't take Terri away from me.

I want to play Terri. I want to give Terri her look. I want to dress Terri.

I am so happy because there is a chance that Terri will stay with us. At the final hour we will have her stuffed. Yes, we will have her stuffed. There will be a wax museum look-alike of Terri. Terri will be in every wax museum in the world. A taxidermist is offering his services to stuff Terri.

Terri is all of us. Terri could be Jerri. Terri could be Larry. Terri could be Mary. Terri could be Cary. If Terri was Jerry Lewis. If Terri was Larry David. If Terri was Mary Tyler Moore. If Terri was Cary Grant. We are all Terri. Do you hear me? We are all Terri.

We all want to go back to a vegetative state in the womb, before talking, before movement in the womb. But still we need to live no matter what. If we could keep them alive we would.

Mel Gibson understands Terri. He has never met her. He understands though. Mel faxed his displeasure with Terri's right to die from a Mexican restaurant. He could not spell her name correctly. He never met her yet he has an opinion. That is what is so incredible about Terri. She inspires people who have never met her to care about her, and make the decisions that doctors and lawyers and her husband want to make. If only Mel could place the wine on Terri's dry cracked lips, Jesus's blood. Terri is being crucified. Terri is being left to die. Terri needs the body of Christ. Terri is an amazing human being.

Arnold Schwarzenegger could take over. Or how about Joan Rivers as Terri? The Seinfeld family could contribute in making a Terri family, in being Terri. Jason Alexander has offered to create a Terri look. The Terri look is a chartreuse green Terri cloth robe. Jason Alexander is a good man. Julia Louis-Dreyfus will help. She will be there.

Terri stands for Truth Eternal Retribution Religious Internet.

Terri stands for Terminal Energy Radically Realized Internally.

Terri stands for Total Escape Reached Real Intentions.

Don't tell me Terri doesn't stand for something just because she can't stand for herself.

2

This is Terri. (*Hold head of cabbage.*) This vegetable is Terri. Eat Terri. She is this head of lettuce. I love vegetables. I love Terri. Could Terri be a fruit? This watermelon is Terri. Eat your vegetables. This is the body of Christ. The body of Terri.

(*Cover body in vegetables.*) I want to get close to Terri. I want to get into Terri's way of thinking. I need to get into Terri's thoughts. I need to get into Terri's head.

Terri, don't leave me. Don't take Terri away from me. When I go to the vegetable store I feel Terri. I see Terri. That's Terri, ladies and gentleman. There is a vegetative state. Does everyone have to be smart? George W. Bush understands what it is like to be in a vegetative state. Terri is about the rights of dumb people. Everyone who is smart, who thinks for themselves, wants Terri to die. Everyone who is stupid wants her to live like us in a state of not thinking for themselves. Does everyone have to think for themselves? Does everyone have to think? Can't you just exist? Isn't that what being a couch potato is about? Isn't that what consumer culture is about? Not to

think? To be just a body of constant attention and the object of our desires?

I lapsed into a vegetative state like I lapsed into my mama. I lapsed into the embryonic fluid. I lapsed into my state before body, before brain, into an infanticized nonexistence. I am the infant Jesus; I am the infant prince of peace.

My wife was never happy with who she was and since she was so miserable I fell in love with the female part of her that was so troubled and therefore she made my masculine self more powerful. Terri always had an eating disorder, throwing up her food. Do I have to talk about this to you? Do you have to know all the sordid details to come to terms with her death wish? Does it matter? Does she fit into a Fritz Perls's Gestalt? Yes, she becomes everyone's projections of their fears. You want to know how her teeth began to rot from repeated bile eroding the enamel. You want to know about her body image, her fainting.

Our favorite game was piggy. We would lie on the carpet, stretched out on the rug, and I would bring her body over mine. I would lie on my back and she would lie on top of me, her back against my belly. I would hold her and cradle her under me and then we would roll. We would roll over and over the carpet until we hit the wall. And while we would play our little game I would make piggy noises. Piggy noises that would delight her. I would snort and oink. Oink oink. Snort. And Terri would join in. Then we would relax in exhaustion.

rmer top FBI official, admits to being Watergate's "Deep Throat." | **06.13.2005** The US Senate issues a formal

You might be wondering how the conversation came up. How the question came up. Well it was after our game of piggy. Terri was in my arms. And she looked at me and said, "I hope we can always play our games, be children together with our children." Then I made a joke like, "I can see us getting old in diapers playing piggy." With that Terri grew quiet. She said, "I never want to be dependent, wearing diapers or spoon-fed when I am old. Pull the plug. 'Cause if I can't oink . . ." Then she laughed and snuggled me with her nose.

What does being alive mean? Terri and I had an intimacy and my love wasn't able to heal her, but maybe . . .

Should I keep her dead? Should I keep her alive? Maybe she was already dead spiritually? Maybe her parents killed her? Maybe.

I could love Terri forever. I would never stop loving Terri. That is what Terri means for me, that I will not stop loving. For if I stop loving I stop living and then where will I be? If we stop love then we stop life and when we love we live. I can love Terri. Let me love forever and ever. I know forever is a long time. But what else is there to do?

What is wrong with depleting your emotions in caring for Terri so you have no feelings left? With no feelings, maybe I will understand what it is like for Terri to feel nothing. Depleted emotions of nothingness so I can coexist with the nothingness of Terri. Some people want to go to Paris. Some people feel alive listen-

ing to Frank Sinatra. I feel alive by knowing there is nothingness in Terri. And maybe if I am able by the grace of God I will be able to feel nothingness. The emptiness of Terri.

Everything costs something. And money and energy and resources come in all shapes and sizes. It takes many drops of water to make the sea. But it is the sea that is the ocean for the fish. How can we say how much is too much? When are our prayers too much, or is the simple prayer of a child the prayer that gets listened to? Maybe we need to keep praying for it hasn't been enough yet for our prayers to be answered.

The expense of life is expensive. Some houses cost a lot and some cost a little. But would we refuse to go back to not building the pyramids? Terri is like the pyramids. Everyone has to work to build and create and maintain Terri. I think that Terri needs to be kept alive no matter how or what or why because she is the modern answer to the ancient need to preserve life. You know how when you look back at what you used to pay for rent it doesn't seem like so much? That is the same way we need to look at Terri. The price is now and we can't live in the future or the past while caring for Terri.

I will give all of my life for Terri. I will dedicate myself to her and never receive love or physical affection except to believe I am with Terri. I don't deserve another's love because then my bond to Terri would not be as sacred. Everyone wants me to love Terri and no one else. I should sit in a vigil by her bedside hoping

a child, conspiracy, and providing alcohol to minors. A fan releases one white dove each time an acquittal

that Terri will hear me and hear my heart and that this is a test of my love of God which is what Terri is about. Do I have the love it takes to love Terri? Can I be a better person to love Terri? No one can love like I do. A pure selfless love.

Once you love Terri you cannot love anyone else at the same time. Everything else stops or has to wait until Terri leaves us of her own accord. It is either Terri or me. The normal life ceases with Terri. Terri's life is a testament to something bigger and more idealistic than our normal life of meals and chores. Terri's life is magnificent. By loving Terri I become magnificent.

My life was once empty and meaningless but now in loving Terri I feel meaning even though I have never met her. I feel a new attitude toward life that I am not a loser. I work at 7-Eleven and I was never very holy or religious but I have found God in loving Terri. That could be me. That could be me. And that could be my feeding tube removed. Then where would I be? Dead. That is exactly the point. This is really about me and not Terri, but I thank Terri for providing me with a way to love myself and value my life for I need to love me before I love others and so by loving Terri I love me and then I love Terri. Terri gave her life for others to love her and identify with her.

There are a lot of people who have never met Terri, who love her, and some people are jealous or feel that they don't even know her, so how can they know what is best for Terri? Well, has God ever met you? And he knows what is best for you. Have you ever met God?

Have you? There you go. We just know sometimes when God is involved, and God had this happen to Terri to remind us what God is capable of.

What is a normal life? Is there ever a normal life? Eventually we all die and we all come to see our Maker. Terri reminds us of that every day. That is why Terri needs her own show. Her own reality TV show so she can be of value to people every day getting ready to die, either voluntarily or by fate, by the grace of God. It's *The Terri Show*. Or, *Make Room for Terri*. The public can see Terri's every move so they can better prepare for what everyone will succumb to. That is why Terri can set an example. She is a teacher, that Terri.

Terri is a nickname for Teresa. And that reminds me of Mother Teresa. It is by no accident that Terri is named Teresa. Terri is a saint. And maybe if she dies that is what God wants, a saint like Terri.

Should I, her husband, date? I know the real groom for Terri is Jesus. But what about me? Should I ever have fun again? Should I ever want to enter another woman? Should I only think about Terri as I enter another woman? Am I to stay in limbo forever, forever waiting for Terri to never wake up? I should never love another woman, never have children. Is that why you are asking me to keep a vigil by her side?

Once someone makes a commitment to love a person, they are not allowed to love anyone else. Even if your spouse is declared brain-dead, you are never able to

brain had deteriorated to half the normal size and no treatment could have helped her. | **06.30.2005** Spa

share your life with anyone again. You can never look at another person with sexual feelings, or feelings of love. All of his feelings should be kept for Terri. If not he'll go to Hell. The world will cave in. The connection, the fear of being left alone can never exist. Her body is in you. You can never have separate feelings from your spouse. For loving someone—in terms of commitment—is supposed to mimic pregnancy. You cannot escape. The other is you, and that is the taboo. Terri is upholding the love between mommy and baby.

Yes, you are miserable loving Terri by not being able to love anyone else as much, and no one else can ask for as much as Terri. How much misery is in the world is in Terri. While I am miserable in loving Terri, it is the misery of Terri, her misery that I love more than my misery. My misery enables me to be empathetic to the misery of Terri and the misery of life. The misery I am in. I am miserable. And Terri is the embodiment of life's misery. My misery. She lives a miserable life and in loving misery, loving Terri, I am saying I am worth loving.

My life is ruined in loving Terri but was it much of a life anyway? Now in loving a life that is worse than mine I can give of what little life I do have to a life not worth living in order to live the life I can.

Those of us who love Terri don't get out much, so the circus run amok is our entertainment. We do not mind the circus routine or shenanigans in describing people who are devout, confused, disoriented, disturbed,

criminal, insane—anyone and everyone loves Terri and we do not discriminate. We do not allow someone to not show their love to Terri, even if they have no idea what they are saying and are crazy. People who love Terri do not have to be rational or reasonable. We invite people who do not have their facts right to love Terri and set their own agenda in matters of faith and state. We invite everyone to live through Terri for all causes. Terri is a champion for the underachievers and the nitwits. Nitwits unite in not knowing much but still loving Terri through it all!

I love Terri like I used to love binge drinking and crystal meth. I love Terri almost as much as I love my daddy who I never met. I love Terri as much as I love my mother who told me I couldn't do a goddamn thing. I love Terri almost as much as I love my drunk father who porked me when I was four. I love Terri almost as much as I love my mother who beat the shit out of me with a belt while telling me to pray to Jesus. I love Terri as much as I love my sister who burned me with cigarettes. I love Terri more than I love the rapist who got me pregnant. I love Terri as much as the mammogram that I can't afford. I love Terri like fast food and no carbs. I love Terri in a way that I wish I could be loved. I love Terri like I love bowling.

Terri is my to-do list. The night before I see Terri, I think of what I can do for Terri and what Terri cannot do for herself. Then I can do those things and then my night has a meaning, for then my day is filled with doing for Terri. What else would I do? Where else would I go?

US Supreme Court, announces her retirement. | **07.02.2005** Millions of people attend Live 8, free concerts

Terri is famous. If I met her before her accident I wonder if she would be my friend. I think she would like to comb my long hair and she would tell me what I should do with my makeup. Terri and I would go to church. Terri and I would go to the prom together. Terri and I would tell secrets, share our dreams, hopes, and wishes. You are my dear friend, Terri. I can talk to you and you listen. If Terri were alive she wouldn't be married to that creep. God knows best but Terri knows even more. For God is Terri.

The most popular female is a victim. We love a female in trouble. Because we see ourselves in her. We prefer women down on their luck rather than a woman in charge. We don't like Hillary Clinton. I don't like the way she talks. There is just something about her. I can't put my finger on it. But Terri isn't like that. Terri doesn't have to lie or say things she doesn't mean because she can't. I identify with Terri. That is why God made Terri.

You asked me if God made Hillary Clinton? Why are you asking me that? Hillary speaks up and out in a way that makes me uncomfortable. Terri is a big pillow that I can lay my heavy head on. With Terri I don't need to think.

I think that we should make a cartoon for the family based on Terri's family. It would be a new show called *The Schiavos* based on *The Simpsons*. The husband would be like the man who owns the nuclear power plant. Terri is entertainment. That is right, Terri can

be a lot of fun. I have thought about the entertainment pitches for Terri: *Make Room for Terri*. This would be a show based on *The Simple Life*. Terri would travel from family to family, town to town, staying with different families and driving them crazy or falling in love with them. Terri would start a product line. Terri would be a fragrance. Terri would be a Happy Meal.

Kill Your Idol: This show would be a different take on *American Idol*. This show would have different catatonic idols who would be wheeled around on stage with their caretakers and then each week one of the contestants would be taken off their life support, voted by America. The contestants would be in makeup. And dressed and used as puppets. They would lip-synch. Terri has a winning personality.

Another show would be *Survivor*: on an island people would be left on their own with brain-dead contestants and would have to try and keep them alive.

Or, *How to Marry a Millionaire*: Twelve bachelors and bachelorettes compete to marry a brain-dead person pretending to be a millionaire.

Terri. What are the first five letters of Terrific? Terri! Terri is terrific, and we are terrific in loving and keeping her on life support forever and ever.

T E R R I. The last letters are F I C and I think those sound out fic . . . fic . . . fickle. We can't be fickle in our love and commitment for Terri.

There is money in Terri. I know some people believe there is money to be made in Terri's death. Maybe that's your reason to keep Terri alive, but it's not mine. You want to know if the reason I am taking away her life support is because there is no more money? Why doesn't anyone believe that fifteen years is a long time to keep someone on life support? It has been suggested that I start a web company with Terri products: a T-shirt that says, "I starved my wife to death." Well, thank you for your suggestions, but I don't want my wife's image on a product.

How can I deny my daughter food and water? Today I water my plants. Let me water Terri. How can I kill my daughter, disconnect her from hope, the ever-present miracle? This mystery of faith and life? For me to say yes, to not feed her, is too painful. It goes against my womb, my uterus, my maternal instinct. If my daughter were born retarded, a paraplegic, I would love her as my child. Is she a vegetable? Is she a savory herb garden, a luscious tomato, an avocado tree? Is she a flowering pear? Let me stand in her shade. The birds nest in her limbs. Her hand can be held but cannot hold. The ivy climbs up her back to be a little closer to heaven. The children build their tree house in her arms, play among her branches. I know the modern ways of cutting timber for a parking lot. The look and feel of parched flesh. My flesh. My pain. I water my garden. I put the milk out for the cats.

Everyone loves a dumb woman.

My daughter's own self-abuse—eating too much, not eating—her fluctuation in weight affected her health. Her eating disorder disturbed her hormones, her fertility. She is now dependent on us. Maybe as parents that is our job, to love our daughter no matter what, and at all costs.

Please, how long was our child married to this man? We raised her. She was our seed, our egg, my body. He no longer wants her to live. Let me provide for my daughter.

The brain. How can we qualify the life force between mother and child? I felt her life in me as I had nausea in my pregnancy. The backaches, the pain of labor, childbirth. Being a mother is painful. I have my baby. Baby wants to be with us or her life force would have left. Terri is our life force, independent of brain and judgment. She is the forever of life. All of my life, my night, my day, I give to Terri. Oh Terri. My Terri. Terri.

ategory 4 hurricane. FEMA director Michael Brown dispatches employees to the affected area, giving them two

days to arrive. | **08.31.2005** National Security Advisor Condoleezza Rice is spotted enjoying *Spamalot* on Broadway and is booed by audience members. | **09.01.2005** Condoleezza Rice is seen shopping for shoes at Ferragamo on Fifth Avenue. When another customer criticizes her for going shopping in the midst of the Katrina crisis, Rice has the woman physically removed from the store. | **09.02.2005** During a live Katrina telethon broadcast by NBC, Kanye West deviates from the script to tell the viewing audience, "George Bush doesn't care about black people." | **09.12.2005** FEMA director Michael Brown resigns. | **09.18.2005** Afghanistan holds their first democratic parliamentary elections in more than twenty-five years. | **10.19.2005** Saddam Hussein's trial begins. | **10.24.2005** Rosa Parks, the civil rights activist whose act of civil disobedience sparked the Montgomery Bus Boycott, dies at the age of ninety-two. | **10.26.2005** During a speech in Tehran, Iranian president Mahmoud Ahmadinejad says Israel should be "wiped off the map." | **11.01.2005** Minority leader Harry Reid calls for a closed session of the Senate to discuss the Bush administration's use of faulty intelligence to justify the war in Iraq and the Senate's failure to investigate it in a timely manner. | **11.09.2005** *The New York Times* reporter Judith Miller resigns after serving eighty-five days in jail over the summer rather than reveal a source to a grand jury investigating the leak of a CIA operative. | **11.2005** The first human face transplant occurs in France. | **12.16.2005** The *New York Times* reports that in 2002 Bush signed a presidential order to allow the National Security Agency to conduct surveillance on Americans to search for evidence of terrorist activity without warrants. | **12.16.2005** *Brokeback Mountain*, the love story of two Wyoming cowboys, opens in theaters. | **2006** | **01.02.2006** Twelve coal miners die in the Sago Mine disaster in West Virginia. | **01.07.2006** A report in the *New York Times* reveals that about 80 percent of US Marines who died of torso wounds in Iraq could have been saved if they had been equipped with adequate body armor. | **01.16.2006** Harvard-educated economist Ellen Johnson-Sirleaf becomes Africa's first female head of state. | **01.24.2006** *An Inconvenient Truth*, Al Gore's documentary on climate change, premiers at the Sundance Film Festival. | **02.2006** A cartoon depicting Mohammed is run in several magazines, which ignites riots and protests worldwide. | **02.04.2006** Betty Friedan, author of *The Feminine Mystique* and founder of the National Organization for Women, dies at the age of eighty-five. | **02.11.2006** Vice President Dick Cheney accidentally shoots seventy-eight-year-old Texas attorney Harry Whittington while quail hunting. | **02.14.2006** Harry Whittington suffers a minor heart attack

THE DREAMS OF LAURA BUSH

Introduction

"The Dreams of Laura Bush" is a first-person, illustrated, dream journal of America's First Lady, Laura Bush. Mrs. Bush dreams with a cast of international celebrities and politicians, such as Tony Blair and Goldie Hawn. Yet, as in everyone's dreams, there is an uncanny mix of the profound and the mundane, and interpretations can come from very personal or collective understandings of life. I'm particularly interested in the symbolic landscape and the unconscious, and how someone with such passive power might sleep at night.

tington's body. | **03.09.2006** Bush signs the renewed Patriot Act into law and includes a signing statement tha

1 I walked into Condoleezza's office. We were in the White House. She had a sitting room. She was taking a rest on a salmon-red, overstuffed chair. I sat beside her. Her room was more like an apartment. I was there to seek her counsel, her advice, on an important question. Condi listened, but responded with, "RIGHT OUT, WHITE OUT."

Simultaneously, as happens in dreams, Condi was talking on her cell phone. I listened and realized she was speaking to the president. She acted as if I wasn't there. I know that the presidency is more important than my needs are. It was then that I realized that I had not asked permission to enter her quarters and how impolite, how outright rude of me. I should show Dr. Rice more respect in the future.

Beside her sitting room was a small bedroom with a canopied bed, with a moss green satin bedspread. Her quarters were in the White House. She had her own guest bedroom.

I left, my question not answered. I left her privacy to speak to my husband. As I was leaving I saw a book on her bed. I read the title, and the title was the same line I had just thought: *I left her privacy to speak to my husband.*

tlines his interpretation of the law, which states he is not bound by its requirement to tell Congress how the

2 It was Crawford, Texas. We were having our own Sundance Film Festival. But our festival was called the Dependent Film Festival. The theme for this year was the high moral character.

We only had one theater built on the ranch. Everyone who attended drove, and parked right in the middle of nowhere. We were in a town that looked like Marfa, where *Giant* was filmed.

Some students gave me their press kits. They were awful, but how could I tell them? I walked out of my pickup and saw a family of eight dogs that all looked the same, with the same name, Taffy.

Lynne Cheney was in the town. There were people parking and walking to the film festival through the town square. Lynne had a dog with her; the breed was boxer. She had more than one, but I only noticed one at a time. One of the boxers came to attack me, to bite me. The dog's lips were soft. The dog was retarded, something was wrong. Lynne walked with her boxers, and all of the dogs attacked the people. I wanted to leave. Why does Lynne have to ruin everything, and bring her attack dogs?

110

accused of raping an exotic dancer they hired for the evening. The men are also accused of taunting the

woman with racist epithets. | **03.30.2006** The Massachusetts State Court rules that out-of-state couples ca

I had to get out of there. So, I went to the apartment I was staying at during the festival. I was staying above a restaurant. As I sat I noticed a person in the other room. I felt the individual was there to harm me. I ran downstairs.

The men working in the restaurant went up to see what was wrong. It turned out that the person was my daughter, Barbara, who wanted to make a nature film. But I felt that meant a sex film. She wanted to be in films. We wouldn't let her. The film was with Goldie Hawn.

*

I was in my room, where a white man from the film festival embraced me. He told me he couldn't wait to see me wear tight jeans and have hot sex with me. He said, "I will have you by winter." He looked a lot like George Stephanopoulos. I thought, well, they both have the name George, so it is okay for me to be attracted to him. He lay on his single bed and pulled up his blue sweater to reveal his developed chest that had hair only on one side.

I was walking out to the restaurant/deli and another young man approached me dancing. I danced and turned around and said, "You are a beautiful dancer." He then said to me, "Make dance, not war."

the German government announces its decision to allow historians and researchers to access up to 50 mil

3 I looked at my hands and they had bones, feather, lace, and delicate strings crocheted with dental floss. My hands were paws, mitts of dental floss, cartilage. They were beautiful. The image was black and white, and Victorian, yet pagan.

President George W. Bush at the White House Correspondent's Association Dinner. | **05.01.2006** Over a million

4 I had sex with an ambassador to the UN from Iraq. I wanted him and felt it was illicit but did it anyway.

And now the end is here
And so I face the final curtain
My friend I'll say
I'll state my case of which I'm certain

Frank & Laura
made love
I did it my way

5 I was living with Frank Sinatra. He played the piano. Frank was singing "I Did It My Way." In the dream, I wake up although in reality I am still dreaming. I wake up in the dream feeling, maybe I should do it my way, for I never have. I looked over at George in bed next to me, asleep. Frank was in the room. I had sex with Frank. George never woke up.

contradict Bush's Christian values. | **05.11.2006** *USA Today* reports that AT&T, Verizon, and BellSouth gave t

6 I was walking down the hill of the Capitol in a procession. At the same time I was in a small village on the river. We were walking toward the river.

It was spring, with cherry blossoms. Karen Hughes was on my right. We walked past a gas station and there was a town square. There was a small, stone-walled garden with a flag. But instead of flowers there was a cake. The cake was decorated for a special occasion. It read "1Y." For one year.

It was Condi's birthday. And Condi was happy. I had the impression that the "1Y" stood for the one-year anniversary of Condi and George's intimate relationship. She looked too happy. She was happy in a way I wasn't. And in the moment, as a wife, I felt the boundary they crossed in their relationship. I was alone.

121

Princess Di looked at me. She was at the party and said, "It brought me to my grave. Don't have an accident."

Karen Hughes walked over and looked at Condi and Bill. George had turned into Bill so we wouldn't notice. Karen said, "I thought I was the only one."

I kept walking. I walked to the river to get my bearings, and then later confronted George as Bill. "But, yes," he said. "It's true. I admire Condi, but I love you," said Bill/ George.

The next thing I knew I wanted to go home. But my airline tickets were with two airlines. My tickets were United and American. I had been with United. I had been united with George. But now I was conflicted about whether I should go American and be moral about George's affair.

*

I was in a house, and a friend of mine was living there. In the dream I wasn't married to George. I was his mistress. I felt better.

122 There was a friend of mine, a woman who cut my hair, who had gained a lot of weight.

There was a wealthier couple (the Calvin Kleins). They spent their time going to the islands, the Caribbean. The Third World was their vacation land.

The couple had a friend with treasures attained from Third World countries. Souvenirs were on display. Most of the souvenirs were kitsch, ceramic works that tourists buy, not fine art. But there was one item that caught my attention. It was a face made of leather. I wondered if it was outlawed by the endangered species laws that protect gorilla hands from being made into ashtrays. Maybe this was an actual skull, a shrunken head.

I felt sick as I wondered if it was a child's head. Then I wondered if it was the head of the boy I killed in the drunk driving accident.

I told my hosts that I had actually been at the island several weeks ago. I felt I was telling the truth but I was lying.

The wife offered to help me with my ticket. I was still wondering if I should be United or American.

I walked into a room that was painted peacock blue with Tiffany stained-glass windows inset into the walls. The decorator got the idea from me. I went to use the bathroom. While I was sitting on the toilet, there was someone else using the toilet upstairs. It was a man, and he raised the seat, and I could hear him urinate. The ceiling started to fill with water. But I quickly realized it was urine. Urine was soaking into the ceiling. For some reason I knew it was my brother or Jeb or George peeing. I got off the toilet and realized I was menstruating. I couldn't cover myself, so I wrapped a towel around me. No one should know that a woman bleeds, I thought. I still bleed, but at least others would know I tried my best to cover pain, even though it is there and others see it.

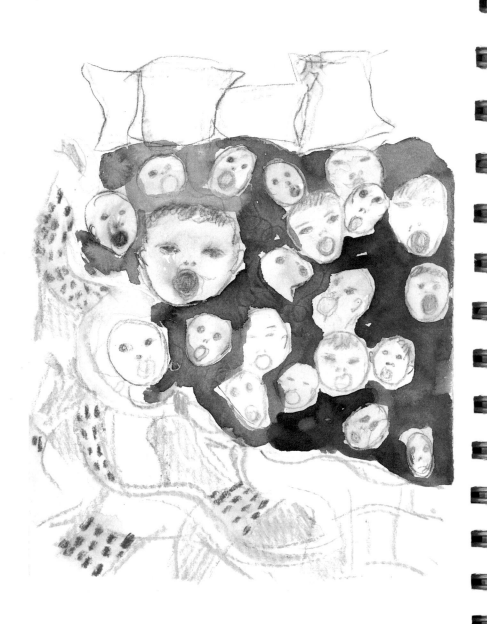

7 I was on a bed with knitted children's toys. There was a young man on the bed with me. He asked me, "What do you do? What are you doing here?"

"I direct. I direct George," I answered.

He pulled the bedspread down, and there was a live image of the bombing in Iraq. I could see hundreds of thousands of children maimed, bodies of dead children. He looked at me and said, "Did you direct him to do this? No child left behind."

drunk driving and is videotaped in a drunken rage, blaming Jews for all the war in the world and call-

ing his female arresting officer "sugar tits." | **08.16.2006** *When the Levees Broke*, Spike Lee's documenta

8 I was in a downtown area. I believe I was in Houston. My body and the skyscrapers were one. At first I felt cells were magnified from my body into buildings. But I was one with buildings, which now I realize is one with nature.

But the thought came to me: there needs to be better planning. Houston has no development plan, just uncontrollable development. Then I looked up, and the buildings were crashing down onto me, imploding.

Then I woke up, and my first thoughts were that I was in a terrorist attack. But I felt we were responsible for over-developing without a plan.

ears

9 I am in a closet. The closet has a shaft that connects to Saddam Hussein's hole. All I keep thinking is, this is a shithole.

While I am in the closet I realize I am in Tony Blair's house. His wife opens the door of the closet. I know she knows that I went to bed with her husband. But instead she opens the closet door and says to me, " I don't believe it." Tony tells her we are just friends. I wonder if I am attracted to ears. I wonder if I am attracted to Tony's ears. George and Tony have similar ears.

I tell Tony Blair's wife a joke. Liz Taylor is going to a plastic surgeon to have her pussy pulled real tight. She tells the doctor, "I want my pussy tight. Real tight. I want my pussy to be the size of a dime." And the doctor said, "We will get your pussy to be real tight." "But there is just one thing, doctor. I don't want anyone knowing about this." The

130

doctor assured Liz that no one would know. The surgery went fine. And when Liz woke up from the anesthesia, the doctor was there by the side of Liz's bed, and she asked if her pussy was tight.

"Oh your pussy is real tight, Liz." Liz was happy. She was taken by surprise. She saw three bouquets of flowers. And Liz said, "I thought no one knew? Who are the flowers from?" The doctor said, "The first bouquet is from me. The second bouquet is from the anesthesiologist. And the third is from the patient in the burn unit who wanted to thank you for the new ear." With that said, Tony Blair's wife says, "New ear?" I realize I have made a big mistake. But she is getting madder. "You just go from George's ear to Tony's ear," she said. "But it's a joke?" I try to reassure her. "You just look at my husband as pussy," said Mrs. Blair. I tell Mrs. Blair I won't see her husband anymore. Mrs. Blair answers, "But he is not interested in you. He is enamored with George."

131

10 I was with George, meeting the president of Brazil. We were in a gym. George felt this represented where he "ran" the country. I knew the president of Brazil, Lula da Silva.

George was on a bike when Lula entered. George put out his hand to shake and I noticed that George's thumb was too short. George didn't seem to notice. George said, "Mi casa, yo casa. My brother is married to a gal who speaks Spanish." President da Silva dropped the handshake and responded, "We speak Portuguese in Brazil, not Spanish." "What's the difference?" George gushed. "It is like the way Tony speaks. We speak the same language, but he sounds funny."

George was sweating and his sweat tears were streaming down his forehead.

"Grab a bike and you don't have to worry about the gas prices. Your people walk a lot, right?"

I looked at my hands and they were lobsters. George
continued pedaling and called out to me, "Honey, can
you make the president a sandwich?" I didn't know
what to do.

Lula, the president, was still standing next to George. His
wife turned to me and said, "Where is your husband's
thumb? Do you have it?"

"Why don't you keep your concerns to your husband?"
I thought defensively. Instead, I tried to make a joke.
"George is all thumbs."

133

"My husband lost a finger in a machinery accident," said
the first lady of Brazil.

Suddenly, the next scene: I am sitting under a table, under
a tablecloth. I put my hands on each president's lap and
they eat my lobster hands.

134

11 My teeth are falling out. No one notices for I'm not speaking. Tony Blair offers to pay for my teeth repair because they have better benefits in England. Tony calls me and says, "Laura, why don't you come to England?" Then he said, "I gave a lot to your country. I supported George. I think you should gum me; you owe me a blow job. Gum me, Laura."

I opened my mouth and I had Juicy candies, the white candies from Good & Plenty, in my gums, where my teeth should be.

I rolled his penis in my mouth, while holding in the white candies that looked like teeth. I felt like a paint roller. Sure enough, Tony had a rainbow penis. "What have you

done, Laura?" gasped Tony when he saw his penis in multicolored hues. "Stop complaining," I said. "If you had Theresa Heinz do it, you would have gotten ketchup and a pickle on it."

While I was on my knees I looked up. We were in a restaurant; brunch was being served. The restaurant had large windows. I heard George. I look out and I see George running down the street without any clothes on. He is screaming, "I don't want to be treated like a baby anymore. I don't want to be treated like a baby anymore."

"The job is really getting to him," I thought to myself.

Sometime later we were with George, and all of his staff were there. David Letterman showed up. When I smile at Dave I have my teeth back.

12

I was having a garage sale at the White House.
I had all of the twins' things for sale. No one
bought anything, not even the Pooh bears.

sion's *Doogie Howser, MD*, comes out of the closet. | **11.02.2006** Ted Haggard, head of a prominent Evangelical mega-church, resigns after reports surface regarding his relationship with male escort Mike Jones. | **11.03.2006** *Borat: Cultural Learnings of America for Make Benefit Glorious Nation of Kazakhstan*, starring comedian Sacha Baron Cohen, opens in theaters. | **11.05.2006** Saddam Hussein is found guilty of crimes against humanity and is sentenced to death by hanging. | **11.07.2006** Hillary Clinton is re-elected to the US Senate. | **11.08.2006** Donald Rumsfeld resigns as Secretary of Defense. | **11.18.2006** Tom Cruise and Katie Holmes get married in Italy. | **11.30.2006** South Africa legalizes same-sex marriage. | **12.15.2006** Governor Jeb Bush temporarily suspends executions in Florida two days after the lethal execution of a Florida man requires a second dose. | **12.30.2006** Saddam Hussein is executed. The event is videotaped by a mobile phone and posted to the internet within hours. | **12.2006** Crocs shoes are noted as one of the year's fashion trends. | **2007** | **01.01.2007** Eliot Spitzer takes office as governor of New York. | **01.04.2007** Nancy Pelosi becomes the first female speaker of the US House of Representatives. | **01.20.2007** Hillary Clinton announces her run for presidency. | **02.02.2007** A three-year study by the Intergovernmental Panel on Climate Change is released. It states global warming is "very likely" caused by human activity. | **02.05.2007** NASA astronaut Lisa Nowak is arrested in Orlando for attempted kidnapping after attacking fellow astronaut and romantic rival Colleen Shipan in an airport parking lot. Nowak had driven nonstop to Florida from Texas, allegedly wearing diapers to avoid bathroom breaks. | **02.08.2007** Anna Nicole Smith dies of a drug overdose at the age of thirty-nine. | **02.10.2007** Barack Obama announces his run for presidency. | **02.16.2007** Britney Spears shaves her head after checking herself in and then out of rehab. | **02.18–19.2007** The *Washington Post* runs a series of articles entitled "The Other Walter Reed" that expose the inadequate and unsanitary conditions at the Washington, DC Army Medical Center. | **03.14.2007** A Pentagon report finds Iraq entrenched in a "civil war." | **03.15.2007** Angelina Jolie adopts son Pax from Vietnam. | **04.04.2007** Radio personality Don Imus refers to the Rutgers University women's basketball team as "nappy-headed hos." | **04.09.2007** President Mahmoud Ahmadinejad announces Iran has the ability to enrich uranium on an industrial scale. | **04.11.2007** North Carolina attorney general Roy Cooper dismisses the case the Duke University lacrosse players who were accused of sexually assaulting an exotic dancer in March 2006. | **04.11.2007** Alec Baldwin leaves his eleven-year-old daughter an angry voicemail in which he calls her a "rude, thoughtless little pig." The message is leaked to the media. | **04.16.200**

GEORGE & MARTHA

Introduction

In 2004 debate was raging about the legalities of the decision to go to war in Iraq. Public sentiment was that members of the Bush administration were in fact war criminals. At that exact same time, the media was also focused on and became preoccupied with the criminal charges of Martha Stewart, who was accused of insider trading.

I decided to write a play, which was then developed into the novella George & Martha *(Verso, 2006), about an imagined affair between George and Martha. I envisioned George W. Bush and Martha Stewart having a romantic, sexual relationship for over twenty years, and meeting in a New York motel room on the eve of the 2004 Republican National Convention. George is waiting to give his acceptance speech; Martha is awaiting sentencing.* George & Martha *is also a reference to Albee's* Who's Afraid of Virginia Woolf, *which was staged in 1963.*

The original production of my play was staged in fall 2004, just prior to the election, with Neal Medlyn as George and me as Martha. We performed nude except for body paint. Martha in jail stripes, George in red, white, and blue.

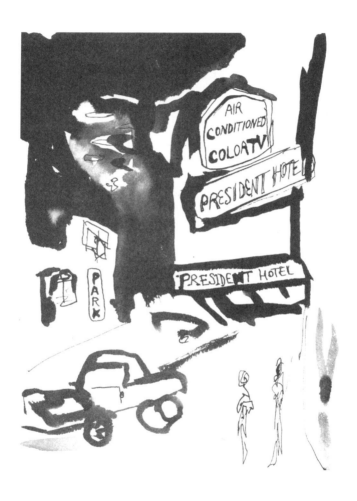

& *Kate Plus 8*, a reality television series revolving around the lives of Jon and Kate Gosselin and their eight chil

GEORGE & MARTHA

Love & War

I know our time together is short-lived. So I relish our moments of quiet. George and I are sitting up in bed, in each other's arms. I am stroking his hands, his palms, interlacing my fingers into his. George loves to feel the soft spot behind my earlobe, the back of my wrist.

But I also need to think about my future.

"George, I need to redesign the world."

"Honey, can't we keep your work out of our love life? I just want to get a little high and watch *The Sopranos.*

"I can go big on this, George, but only with your help. It is more than infrastructure, George. We can redesign America with a Middle East accent. In the fifties, after Pearl Harbor, Hawaiian themes overtook home decor. Everyone was wearing muumuus, and throwing tiki parties. Now, with my connections at Kmart, everyone in the US can be pitching a tent and building their own mosque."

George chided me, "Sweetheart, I know we both are involved with domestic issues, but Kmart is not Iraq."

"Kmart isn't Iraq, but that doesn't mean Iraq can't be Kmart."

"Honey, I hate to disappoint you, but Cheney isn't making money in shower curtains."

George never listens to me. I face him, hold his shoulders passionately and continue my plea.

"Everyone has a kitchen, George. Give me a chance. I want to redo the lifestyle in Iraq. This is more than religion, George. Once I introduce a culture to shabby chic and extra virgin olive oil, they'll pay lifetime dues to be in Martha's club. We are talking utensils. Utensils, George. Utensils! Everyone needs a utensil. Everyone needs an herb garden!"

I get so excited, just thinking about the possibilities.

"Not an herb garden, Martha. We want them to buy things, not grow them. Cheney thinks it's all in fast food."

"Cheney? You are listening to that bald-headed, uncouth fart machine on his sense of style? George, you are going to need me. America needs me. I can transform the horror of the panty headdress into dust ruffles. I can transform the hooded prison garb into the perfect black dress. I have the solution, George."

I should be running this goddamn country.

"Easy, Martha."

"Maybe Cheney's right, but why wait for him? I want to open McMohammed Kabob. It's a good thing!"

George looks at me perplexed.

"Look, George, Sony in Japan was started with American money. And if we are lucky, if we play our cards right, Mickey McJesus will be coming in a six-pack on the Gaza Strip."

Using the Jesus calling card always worked in drawing George into the conversation.

"You're right, Martha. These people need to liquor up so they can find our god our way. It's time these people learned to take the edge off with alcohol. That's the way I found Jesus. With alcohol. Drank myself to oblivion until I found the Lord."

"George, we don't want them to be shitting red, white, and blue. Only wiping their ass on the good old USA greenback."

"We could bring in McDonalds, Disney, throw in a theme park and call it Mickey McMohammed. Make a movie, a cartoon on the Passion of Mohammed. Make Mohammed a mouse. The Moslems need a mouse. A Moslem mouse. A Mouslem. Make Mohammed a mouseketeer. Then we get the kids meals and toy franchises and everyone is happy."

George is on a roll and can't stop.

"And another thing," continues George.

"Make it a good thing!" I think I have him. It's a slam dunk. But all of a sudden George becomes hesitant. It's the cowardly George, indecisive, exasperated George. Here it comes. Here comes WASP culture. He is going to be concerned about what others think.

"I don't know, Martha. It might not look good."

"Might not look good? This is a new George. Since when have you been concerned about appearances?"

"I want to save the theme park for when I leave the White House."

"Oh, don't start now with priorities, George. You can never be spontaneous. Oh, go read a book with Laura and turn on the night-light."

I am annoyed.

"Martha, I can never process anything with you."

"Okay, I'm listening." I cross my arms defensively.

"I plan . . . " starts George.

"Oh, George has a plan." I'm sarcastic. He is revising my vision, my fantasy.

"I plan to make a theme park based on all the presidents."

"All the presidents? Really, George? That is quite an undertaking." Now I'm cynical.

George does his best to ignore my cynicism while maintaining his vision.

"It will be a theme park based on all the presidents."

"You just said that dear. All the presidents. Don't need to repeat yourself." I am in kindergarten.

"It will be a theme park based on each and every presidency. And considering . . . " says George.

"Considering . . . Sounds very NPR. Sounds liberal, considering?"

"And considering . . . " George repeats.

"Are you really going to consider everything, George? Are you? Are you considerate, George? Really, George, you have never considered anything except the easy way out of anything."

I am raising my voice and ready to give him hell.

"Since there is always a new president . . . " says George.

"Never knew that, George. Thought we were in a dictatorship or monarchy under King George. Thanks for telling the subjects!"

George and I always clash whenever we discuss the future. I know that I am not in his plans. And I realize how little emotional security I have.

George's face slowly becomes the color of Red Bull.

"Since there is always a new president, the theme

own after increasing protests of UK involvement in Iraq war. He is replaced by Gordon Brown. | **06.29.2007** The

park will continue to grow and grow. And I will make appearances. And my library will be there, too."

Yep, George is mad in the bullpen.

"Since you don't read, there will be plenty of open space for Frisbees."

I have to tell the truth, so help me God. The conversation is going nowhere with this idiot. I get up and put on my floor-length negligee. I catch my form in the closet mirror. I am hoping for a minute that maybe he will just stop thinking about all of these plans and look at me, be with me. I see my silhouette and I wonder if maybe I no longer please George. Men are so dependent on the visual. I wish I had gone on the Atkins diet before seeing him. But during the stress of the trial I had to have my comfort food, and I puffed out. Maybe when I'm in prison I can skip the carbs and trim down.

George shoots up from the king's throne. He knows I am smarter than him and he hates me for it.

"What do you want? A theme park for your people, the Pollacks? You're not a Stewart. Stuart is the surname of the queen of England. You're a Kostyra. Martha Kostyra. A Polish Catholic eating stuffed cabbage and wearing a babushka."

He follows me into the bathroom. I turn on the shower.

"I admit it, George. I don't like who I am. But I am so tired that every opportunity you get you belittle my ethnic heritage," I say, waiting for the water to get hot. I take off my negligee and hand it to George to hang on the door while I step into the shower.

"You think you are the only one entitled to not like who you are, Martha? I don't like who I am. But I

am not allowed to hate who I am because I have all the power. Is that it, Martha? You had to work for it. And we all have to pay now. Bitter, resentful Martha. Well, I hate my parents. I hate my life. I hate myself. I hate this country. I hate Martha, for being more of a man than I am."

I soap with the small bar of motel Ivory and a threadbare washcloth. Now George has started something he will regret.

"Oh, is that supposed to hurt me now, George? Put me in my hurt place? Let's start the game, George. Let's play motherfucker. I can't help it, George, that your mother Barbara was the real father of this country. That Barbara was the real George Washington of this country," I shout over the water pressure.

"Don't start Martha . . . "

I peek out of the curtain and let the shower hit my back.

147

"Enough with your father. Let's see how your mother fucked you up. Your mother was the real man in the family. She even looks like George Washington. You thought your mother was a man, right George? She is in drag, walking around with those fucking pearls. She married your father and gave birth to a president. She is probably the only woman to be fucked by two presidents besides me. You are a motherfucker, aren't you? A real motherfucker. Fucked your mother right in the birth canal."

I know I am going a little hard on George and his mother. But probably it is because he never finds a damn thing wrong with her. He is such a mama's boy. I want to strike out at her. Strike out at their special relationship. Why do I want to hurt him so much?

Maybe this is all projection and I am really talking about myself. Am I the man in my marriage? Am I the ultimate provider, protector, and punisher?

I hand George the soap and cloth to scrub my back. He joins me in the shower and starts washing me. George lathers my skin as he speaks.

"So you want to put me on the couch now? You have me fall in love with you, fuck your brains out, and then you start fucking with me. And you call me a motherfucker? Do you think I am fucking you because I really want to fuck my mother? Is that what you are telling me, Martha?"

George is mediocre in his attempt to explain himself. And now I feel out of control. I turn and take the soap from him.

"Hahahaha, I always thought you wanted to fuck your father," I say just to confuse him.

We change positions and George gets under the water.

"Oh, I give up, Martha. Why don't you run for president? Oh, you can't. You're a convicted felon. I can't even get your vote," George says vindictively.

He turns around and I start washing his back and shoulders.

"Don't even try to be competitive with me. You aren't smart enough. You're a stupid little Bush. You were named after a vagina. Sissy little pussy Bush."

I finish lathering his back and put him under the shower to rinse off.

"Stop it, Martha." He sounds pitiful. From my perch, I start to pity him but I'm also getting hot. I think he is, too. I start slowly washing between my legs, my labia, foaming my pussy folds.

mona goes before a congressional committee and testifies that high-ranking Bush officials prohibited hir

"Poor George. Should have been a gynecologist with a name like that. He was only good at looking at pussy. But George couldn't have gotten into medical school if he tried. 'Cause he's a stupid little Bush. A humiliated Bush. A stupid Bush with attention deficit. Can't hold a thought. Can't come up with anything on his own. No ideas."

I say this slowly, with my fingers on my clit.

I take my hand out of my snatch and bring it over to his hard cock. I grab his cock and give it a little pull and hold it tight.

"Please, Martha, stop. Please. Stop. Please stop. Please."

For a moment I act like the kidding has stopped. I kiss his ear and nibble his lobe and whisper in his ear.

"A Junior Mint Bush."

George is holding his ears.

"Don't call me Junior."

I am laughing at him, "Can I call you . . . mama's boy?"

I turn off the water, thrust open the curtain leaving George alone in the tub, and gather one of my lavender Martha towels. I dry myself and wrap a towel around my body.

For a moment I think I should let him go down on me. My puss is in agony. I'm throbbing, pulsating. I want to fuck hard. But I have to do everything in this relationship. Even the fucking. I'm over it. Everything seems comical all of a sudden. Everything seems surreal.

"Who's the real George? George Washington? Then I am Martha Washington. I am the first lady after all,

m reporting on stem cells, emergency contraception, and global and prison health. He also states he was

150

George. George and Martha Washington. George and Martha. Hahahaha. Like in *Who's Afraid of Virginia Woolf.* You probably don't even know who Edward Albee is!"

I turn on the blow dryer and tousle my hair with a little product.

George is relieved the subject is changing. "Wasn't he in *Green Acres*? I loved that show."

George gets out of the shower. His mood is happier. He uses the towel I dropped on the floor.

"George, that's Eddie Albert, not Edward Albee. I can't believe that you don't know one of the most influential twentieth-century American playwrights. Didn't you at least see the movie?"

"If it was in black and white the answer is no." George uses my toothbrush.

"How can someone so stupid be in control of the most powerful country in the world?"

I look at George over the sink.

"Come on, George, give me the stupid look. You look so cute when you look so stupid."

George rinses his mouth. He seems defeated, but also like he doesn't care. Which makes me meaner and madder.

"I wish I was smarter for you, Martha."

I turn off the hair dryer.

"George, you must have some redeeming qualities. What are they again?"

I brush my teeth.

"I wish I could have more courage, more strength, more intelligence."

From the side of my mouth while brushing, I tell him, "The whole world is laughing at George."

"Laughing at me?" He rolls on antiperspirant. I rinse.

"Don't you get it? You're the man with the weapons of mass destruction. You are the one who is out of control. You are the evildoer. Haven't you ever heard of projection?"

I know I'm right. And I'm not turned on anymore.

"Do you have to ruin my weekend? You always have to ruin our weekends, Martha. Whenever we have any time together, this always happens."

George gets a drink. I put on some raisin lipgloss and apply eye crème. I'm annoyed with him, and I'm not going to let that go.

"Don't you understand anything about psychology? Saddam is your shadow. You're the man in the hole. You are Saddam Hussein. You are always saying that Saddam wanted to kill your father. The reality is that you feel so guilty about your own feelings of patricide, you disguise the taboo through your desire to capture and destroy Saddam."

Shit, I'm better than Doctor Phil.

"You really know how to hurt a guy. There goes my hard-on."

"Yes, George, you just said it. Your father makes you impotent."

"Don't turn my words around. I'm fucked up, but I love my parents." George is still in the bathroom putting some gel in his hair. He looks in the mirror. He needs a shave. He takes out the razor.

"Martha, I haven't done anything wrong. I am just trying to bring the democratic process to the Arab world."

"And the Iraqis will say, 'I lost my entire family

during American bombings, but I will be able to cast a vote. Thank you, America!' Now that's freedom." I sneer sarcastically.

George comes out of the bathroom and stands over me on the bed.

"That's right. This is about morality. It is about punishing insurgents and their impulses to kill. I know there are good Iraqis. I feel for the mothers of Iraq. Many of the children no longer have fathers. And the mothers have to provide. But the oil will flow. Oil is what makes America run. It is what our economy is based on. And Iraq has to understand their place in the world, even if it means being destroyed in the process. My father didn't understand this. I wish he did. Then I wouldn't have to be taking care of this."

"Have you ever thought, George, that your intense yearnings and passionate feelings for Iraq are perverse? That it's sexual tension, George?"

I am starting to get hungry. I guess we could order in. Maybe I'll get a BLT.

"This isn't spin the bottle, Martha. I want the best for Iraq. I love Iraq."

"That's right, George. Iraq is the love of your life. Iraq is your girlfriend. Iraq is your bitch. Iraq is your whore. Iraq is your cunt. Iraq is your love object. And you have fucked her good."

"I am going to pretend I didn't hear that, Martha."

"George, Iraq is the mother that you control and destroy. You greedily devour her milk, her oil, and you kill all of her children. You occupy and invade your mother. Your preoccupation with Iraq is maternal stalking madness."

"What do you want to hear, Martha? What do you

want from me? What do you want me to confess to?"
He is shrieking.

I need to eat something. My blood sugar is falling.
I pick up the phone and order sandwiches from the
deli.

George tries to show remorse for his past.

"Okay, I slipped. So I shouldn't have stopped going
to meetings." George was making sense, trying to
calm things down between us. But it's no use. I am
on a rampage.

I pretend I am drunk with a Texas accent, "I know
it is our fault, the country's fault, for giving me the
money. I don't know what happened to the money.
I had money when I came into office and before you
know it $300 billion is gone and hey, what's a trillion?
Who's counting when you are having fun? We are a
rich country, we'll get it back. One day at a time, with
the help of the higher power."

There's nothing like a dry drunk. I pour myself
another drink. George is already finishing a beer.

"I didn't spend anything we didn't have, Martha.
I mean, it's only money . . . and a few lives. But I
know you only care about the money. Maybe if you
weren't so concerned about your company you could
have concentrated more on me and I wouldn't have
been so lonely. I wouldn't have been so desperate.
This is really all of your fault, Martha. It's all your
fault. You weren't there for me. You were only con-
cerned about your profits, your company, you you you.
You really know how to ruin my weekend. You always
have to bring politics into everything. You think too
much, Martha. Maybe if you loved me for who I am I

154

wouldn't need to act out. Martha, all I need is to be loved."

I turn my back on the idiot and watch the twins at the convention on the TV. I wonder if George and I had had daughters, what they would look like. For a second I consider that maybe my eggs were taken out of me and inserted into Laura . . . But that's crazy. I have to get off the sauce.

"Do I have to love your death instinct?" I ask.

George comes over to the bar. God, he is drunk. I look back at the TV. I feel sorry for Laura. She doesn't even know how to pick out a dress. But then there's me. I suddenly feel lost and empty.

"Yes, I like to keep the nation at the pulse of a trigger. When someone is holding a gun to your head and the trigger is about to be pulled, you don't know if you're going to be alive or thrown into chaos. I'm not fighting the war, the war is fighting me," argues George.

I want to shake him out of his insanity.

"Stop playing those mind-fucking games like my father!" I shout.

I'm confused. Oh, I wish this would all stop. I wish we could start the weekend over and just love each other.

"I I I love you, George, but I hate the way you make me feel."

My voice is sounding shrill, which I despise.

"I don't know why I always come back for more. I just get so desperate. You have the twins. You have that doting wife. All I have is a refrigerator to fill."

I try to be affectionate.

Please show me affection.

Suddenly, I need his love, his understanding.

I continue: "So I have abandonment issues, separation anxiety. Everyone has something. But I stay with you, George. Maybe it's better to feel abuse than to feel nothing at all."

I look up at George, my lover, and speak from my heart for the first time all night: "I am afraid of being loved so I love being hated. I'm afraid of being wanted so I want to be abused. I am afraid of being alone so I alone become afraid. I am afraid of being successful so I successfully become nothing.

"All I want is to create the fantasy that maybe we can live in a more beautiful place even when evil lurks in the hearts of men."

I look down after my speech and George very gently holds my wrists and brings my hands to his lips. He kisses my palms and then holds them tightly together as if my hands were his hands.

"Bravo, Martha. Did you write that yourself? Martha, you are the one in control. Martha, how can I be in control if you are? Martha always knows what's right. Martha knows best. Martha the know-it-all. Martha never makes a mistake. Do you, Martha? Do you feel better, Martha? Thank you, Martha, for putting me in contact with my stupidity. But Martha, you need stupid, inept subhumans like me to maintain your sense of entitlement and grandiosity. Because actually, Martha, you don't feel worthy. Martha, you are the one out of control with your anxiety. Yes, Martha, I feel so out of control. Martha, I want to destroy the world. Destroy America. Destroy our economy.

Destroy young happy Americans with a future. Destroy culture. I enjoy seeing youth die. Not because of oil, Martha. But because, Martha, I am evil. I am evil. I am the evildoer. Martha, I am in control. This time the stupid idiot calls the shots."

I spit in his face. The sandwiches should be here by now.

158

would fund 900 programs, including $3.5 billion in aid for areas destroyed by Hurricane Katrina. The Hou

Love Hurts

Later the same day George and I are sleeping peacefully when suddenly, without warning, George bolts up in a panic.

At first I think he was having a nightmare, screaming and kicking. I can barely see him in the dark.

"AHAHAHAHAHA!!!!" George screams.

I am jolted by his distress. I try to orient myself.

"What is it, George?"

I turn on the bed light and I see George is as white as sin itself. He is having a hard time talking, he is so frantic. I hope he isn't going to throw up. I hate the mess.

"George, what is it?"

George is crawling around the bed on all fours. He is a caged, rabid animal. It's like his skin is turned inside out.

It's always something with George.

I want to go back to sleep. I want a romantic, sexy weekend. For a moment I envy Monica Lewinsky. Yeah, give me the cigar and the dress. You bet I'm a friend of Bill's.

But then George snaps me out of my petty identification with Monica.

He reveals his news.

"Bin Laden is in me! Bin Laden is hiding in me! I swallowed bin Laden," shrieks George.

George isn't just hysterical, he's foaming at the mouth. I feel like throwing a fizzy into his trap, locking the door on his hallucination and dropping him off at the rubber room at Bellevue.

Please God, what should I do with this lunatic?

As usual, Mommy takes over.

"George, settle down. You are just having a crack attack."

Maybe I should call Barbara, I think to myself. How do I deal with a situation like this? Should I check my speed dial? Believe the bastard? Go along with him? Now that's an angle.

"He's in you, George?" I ask with genuine concern.

"Yes, bin Laden is in me, Martha. You got to get him out. He's hiding in me."

We are both on the bed. George is on his knees crying for help.

"I need an exorcist. Get me the Vatican! Get me Barbara Walters! Get me *Trading Spaces*. Get me *Queer Eye for the Straight Guy*. Get me Craig's List! Get me out of me!"

George has his finger down his throat and is trying to throw up. I am prepared to call man overboard.

"Let me have a look, George." I grab my handy flashlight that I keep on the edge of the bed and get on my knees and peer into George's throat. George sticks out his tongue and opens wide.

"Do you see him?" asks George, as if I would keep the information to myself.

"I don't know if that is a tonsil or a terrorist." I

decide to go along with the hysteria. (I'm glad he can't get a third term.)

"You can't tell the difference?"

I'm straining to look past the gold bridgework. But I don't see bin Laden.

"Are you sure he came in this way, George? He could have come in the back end."

George sits on his haunches and gives it a thought.

"You've got a point, Martha. I thought that was your finger I felt . . . "

George gets on all fours and moves his bottom up into my face. What an asshole!

"It will be more than a finger, George . . . when Homeland Security comes in . . . "

"Homeland Security, *Home Alone, Home Improvement.* Drop the Tim Allen and look up my ass," commands our commander-in-chief.

161

I adjust my flashlight. George pulls his cheeks apart.

"George, I think I see him. George, he's in there. He's waving. He's in the canyon, the mountains," I gasp.

"Yes, there he is. Oh, for God's sake, for Allah's sake, there is bin Laden. And he's tall, too." George stays on all fours.

"Yeah, he's fucking with me, Martha. Either I am going to have to shit him out or take it up the ass."

Don't give up now, George.

"George, I wonder what would work better, a coffee or wheatgrass enema?" It's the best I can offer.

George peers over at me.

"Martha, why don't you stop using my colon for comparison shopping? The problem with you liberal types is that I have bin Laden up my ass and you're asking why. Honey, my ass is Central Intelligence so let's keep the whys out of it."

Oh, the familiar George is back. I am relieved.

His tone is starting to normalize. The panic is subsiding.

"If only we could trade places and I could go to prison like you . . . You know what happens in prison," reasons George.

I sit back and wonder for the last time, What is in this for me? When I realize there is nothing, my sarcasm returns.

"George, maybe you have something here. This is a great photo op. Let's put a hood on you and leash you up. Grab your nuts, put the dogs on you and I have my November cover for *Living*."

"Do you have to turn our personal life into a media opportunity? Living in a president's asshole?"

George mopes. "I wish I could take your place. If only I was going to prison like you."

He's rubbing a little too hard with the wipe. I might have to take it away from him. What a baby.

"You aren't going to absolve yourself through my jail sentence."

It's time to start packing my things before another *America's Most Wanted* shows up intravenously. There is only so much I can take.

"It sounds like a vacation if you ask me," George says with a sneer.

"A vacation?"

I know the insults will be next.

"You are always so fucking busy with tedious, unimportant, meaningless tasks. You are so anal, Martha."

I knew it. George sees me packing and he is mad at me for leaving.

"George, don't get angry with me because bin Laden is making you use your sphincter."

"You drive me crazy, Martha. Your mad need for order, order, and more order. There is nothing sexy about you, Martha, except maybe your attention to detail."

"George, don't even try to figure me out. Let's not ruin a good thing. I have my own way of doing things. It helps, George. Every minor detail takes on a life of its own. The closet is my executioner. I move toward the closet, or a pantry, as if it is a guillotine. I open a door in dread, searching through hangers, sorting through drawers . . . "

The room becomes cold. The mood changes. I'm leaving. Mommy is leaving.

George is making the separation easier by making it difficult. George is going insane, not making sense. He is a child. I will have to spell everything out for him.

"Don't start now, George. Let's not ruin a good thing. Let me leave now and go to prison. And I will see you when both of us are out of a job."

"Martha, you are talking to the guy who was designated by God to be in a special place of power. So let me play God, not you. You aren't leaving me. God doesn't want you to leave me. If you leave me, I will die, Martha. I am nothing without you."

I put on a zebra wraparound skirt, but the belt is too long. Poor design.

"God? Can we keep God out of our relationship? Can we set a God boundary? God doesn't want me to go? All I remember is you played God when you wanted me to have an abortion." Now I said it. Now I finally told our truth. I expect George to have feelings of regret. Instead . . .

"Martha, I wanted you to have an abortion because I didn't want a devil giving birth. You would suffocate our baby with all of your . . . I am sorry Martha . . . I shouldn't have said that our baby died," laments George, abruptly changing his tone.

I stop my packing. He has crossed a line. He has to hurt me.

George is like every other man. If he hurts then everyone will hurt.

Here I am going off to prison and he says everything and anything to hurt me. My heart is in my belly. I want to be with my daughter. At least I have her.

I decide to be a better mother. A better person for her and for me. All of a sudden I realize I've been living for everyone else and not for me.

"I should have called my magazine *Dying. Martha Stewart Dying.* All of my hard work, all of my efforts, all of my energy is to keep from dying. My emptiness creeps up on me and I do more and more: iron a shirt, prune the roses, can the tomatoes. I could be pulling the trigger, but instead I'm pulling the weeds. I could be slicing my wrists, but I am slicing the beefsteak tomatoes. I could be hanging myself, but I am hanging the sheets out to dry in the sun. I could be putting a hole in my heart, a hole in my head, a hole in my soul, but instead I am putting a hole in my plaster wall.

165

"These are my rituals, my own deal makers to stop myself from dying. In doing I lose all sense of myself. I have become Martha the Machine. Martha Non-Human. Martha Not-Living."

I feel so low. My life feels like nothing. I have nothing left.

George starts to get dressed too. He pulls on his dress slacks and a blue shirt.

"Martha, you know this whole case of insider trading is a setup. We want you to join the CIA, give you a cover, and work on a special project. That's why you are going to jail. You are working for us now."

"No, George. I am not going to work for you. For years I protected myself from the feelings I never dared express. No one can make Martha suffer. Martha can endure any pain. No one can hurt Martha because no amount of pain can equal Papa's hurting me." I cry.

George is watching me pack. I am putting all of my accessories away.

"Okay, Martha, trump me on the bad childhood but look, I'm a puppet president. It was either this or becoming the biggest coke dealer in Texas.

"Baby, you aren't going to jail. Look, baby, I love you. And that's that."

George looks at me like I am his daughter, and for a moment I want to weep. For a second I want to be saved. I want to be rescued. But it would only be temporary. It would only be in George's best interest.

"But I want to go to jail. I need somewhere to go. I need to be looked after and cared for. I need a father's protection. I need to be punished and taken care of.

That's why I need jail. Don't tell me what I need. Don't make my decisions for me."

George turns away and mixes a drink.

"You're not leaving me, Martha, and that's that. Now it is all set up. You don't have to go to jail. Why do you insist on the drama?"

George certainly could be competent when the need arose. But I always resist his daddy act.

"Papa never recognized my suffering. He said things like, 'You have no idea what suffering is.' Now maybe in prison I will finally be able to suffer in peace. I always thought that to suffer you had to be really special. I worked hard at being special. But I was never special enough. Maybe now I am special enough to suffer."

I zipper up my overnight bag. I think I'll throw this one out. This is the last time I will look at this luggage.

I wonder if Bloomingdale's is still open . . . Maybe I should design a line of luggage.

Stop it, Martha! I always detach from the present.

"Do you really think you did anything wrong? Martha, get real. None of the players are who they say they are. Noriega. Saddam Hussein. Shah of Iran. It was all part of a deal. That video with Saddam in the hole—you think that is real? This government is a fantasy, just like your linen closet. But then, you wouldn't understand. You are only a caterer, Martha."

Didn't I tell you? The moment I have my bags packed and zipped, he deals the final blow and ruins our time together for good.

"I'm only a caterer? What? I could give you my childhood on a celery stick, my family background on a welcome mat, my college years in a sachet, my *Martha Stewart Living* cross-stitched, my domineering personality neatly ironed and heavily starched, my public image in foie gras, my bank account in onion skin, my frenzied schedule in India ink, my tortured, calloused, bruised, tethered, scrubbed hands of a Polish peasant woman, my prom dress of handmade calico rags, my hysterectomy . . . Because if I was a man I could have done a better job than you!" I say with the air of a CEO.

"Yes, anyone could have done a better job. But then again, I wouldn't call what you do a job."

George puts me down to the core.

"It's not a job? My job is as live-in domestic for the nation. It's slicing and dicing. It's baking basting beating brewing broiling canning chopping digging drying filleting folding freezing frying grating grilling icing making mashing mopping nesting peeling poaching pouring pruning pureeing roasting sautéing scrubbing sewing shopping sorting steaming stewing stirring tiling toasting washing whipping.

"I know apples. Rome beauties, Empires, McIntosh, and Gaia organic. I know brunch, breakfast. I know candles, glazed carrots. I know dessert. I know eggs, omelets, hollandaise, Florentine. I know gingerbread houses. I have New Hampshire in one hand and Ireland in the other. I know jams and jellies. I know kettles. I know lemon zest. I know marjoram, mopping, and moisture. I know the blue of robin's eggs in nests, I have owls and ovens. I know poaching. I know potting. I know quilts. I know risotto. I know thyme,

tarragon, and tasting. U You You You Victory vases Y Why? Why? Because it all adds up to a big fat zero."

I pause and catch my breath.

"I am the nation's mother and everyone hates their mother."

I am crying. My heart is on fire and my passion has burned out.

"Don't take it so personally, Martha."

"George, the only thing you have personally accomplished is failure."

I pick up my suitcase and turn toward the door.

"Oh, go on, Martha, why stop now. Continue with Life According to Martha."

I need to break free, but George stops me. He holds me. I can't get away. I am getting claustrophobic. I need air. I need freedom.

"Why don't you do something that is more in tune with your abilities? Why don't you do something about parking?" I snarl, looking straight into his eyes. Suddenly I feel like I am standing up to every man who has taken advantage of me for being female.

"How horrible are you, Martha? How hateful is Martha?"

I wonder if he is talking to me or to himself.

"You hate Martha. I hate Martha! Everyone hates Martha!" I shout.

I am defending myself. I am trying to break loose. I am clobbering George with the suitcases. Look at me! I have always been so good. I was the good girl. The good daughter. The good wife. The good student. The good mother. The good neighbor. The good employer. But I guess I was never good enough.

"I hate you, George. I hate you. I hate everything

about you. Do you know what I love most about you, George? Hating you. I love to hate you."

I calm down or maybe I give up. Does it matter?

George's expression changes. "It's moments like this that I realize I can't live without you, when you are more incoherent than me . . . Don't leave me, Martha. You can't leave me. Not now. I love Martha. Not the do-it-all Martha, but the vulnerable Martha. You can do so much, I know. But I can make you smile, take your mind off things, make you laugh. You're my little girl. See, all I got from my parents was, 'Not in this family, George. That's enough, son.'"

In the final analysis, George always has to make it about him. He is such a narcissist, and I am merely an extension of him. He'd never understand me. Why have I spent so many years expecting him to?

"George, I didn't have the goddamn privileges that you were born into. You were expected to rule the world whether you couldn't, shouldn't, or wouldn't. I was not expected to be talented. My reality is every woman's reality. I am being abandoned by society for refusing to be the weaker sex, refusing to be passive, refusing to be as cute as possible, to be as desirable as possible, as boring as possible. Yes, Mr. President, I took the unpaid housewife and gave her a fair deal, I gave her life meaning. I gave her value. My crime is that I am not sorry. I am not sorry. So, lock me up!"

I look straight at him with the strength of a mother who can pick up a car if her child is underneath. I have adrenaline rushing through my veins. I feel the years of work of all women. I feel the tireless, thankless work of women as nurse, cook, and maid.

"I have always thought of you as a domestic ter-

he US presidential primaries begin. | **01.22.2008** Actor Heath Ledger is found dead from an acciden-

rorist, Martha. Your own hyperdomestic designer version of terror, of a controlled lifestyle of abuse. Don't worry, Martha. We have a special relationship. You won't be going to prison."

I put on my gray, sequined, crocheted shawl over my shoulders, slip my white, patent leather sling backs on my feet, and place my hand firmly on the doorknob.

"George, I am always told to remember those less fortunate than myself. To remember the homeless, the poor, the suffering. Well, I am suffering inside! Any time I see anyone caring, sharing, loving, I break down inside with envy. That's why I want to be locked up, because I will feel comfortable surrounded by the less fortunate, the broken, the collapsed, the guilty . . . Because it looks like how I feel inside. It looks like what I feel like inside. So don't take that away from me, the one thing I earned on my own . . . my own punishment on my own terms. I want to feel. I am no longer going to feel the only feeling of no feelings at all."

Tears are running down my face. I feel so lonely. I know I won't be missed for being me, but for what I can do for others, for George.

I am so distraught, I don't realize how drunk George is. I should order him a double espresso. Look at me, I just can't stop thinking about others' needs . . .

George has more to say.

"Yeah, I'm lucky. I'm so so lucky. I hate people. I hate people who rationalize luck. I hate people who have to have a reason for everything. They just can't accept evil. They just can't accept that good things happen to bad people. Or that bad people have good

luck. I admit it. I am out of control I am out of control. I am out of control!"

George becomes a stranger, so distant to me, right then and there.

I turn the doorknob and start to walk out the door.

"Martha? Martha! Don't leave me. You're not going anywhere. I need you, Martha. Martha! Baby. Baby. Baby." His voice is part of my past now.

I stand by the door as it closes. I think he will run after me. But I guess that is my vanity. I need to stop being needed. Oh, this hurts too much.

From the closed door, I can hear George is doing just fine. He is talking to himself. He is probably finishing up the coke, checking the convention on the TV.

I stand alone in the hallway and listen.

"I hate independence. Independence Day. I don't 173 need to be dependent on Martha. Hahaha. I want Dependence Day. I want to be dependent on drugs, alcohol, sex, and a woman I don't love. I want dependency. I am taking away all the independence of this country. I will take away abortion, I will take away freedom of speech. In George's world no one can talk because everyone becomes a baby. Baby Nation. This stupid flag—wave it wave it, Daddy! Wave the flag. Wave the diaper. We're all in Depends in this country. Yeah, I care more about the flag than I do about my own citizens' hungry bellies. I care more about a goddamn yellow ribbon, like it's your binky, your pacifier, than I do about people dying in Iraq. Homeland security, what a crock . . . Let me tell you, God has failed. God is bureaucracy. God is statistics. God is the price of oil based on the euro not the dollar. God

is my father when you don't have a father who loves you, who wants you, who believes in you. God is what you make and not what you feel. So you see, Martha, I am a very, very religious man. I live in a state of never getting better. I live in a world of caving in. I live a life where pleasure means death. It's a life of lies, Martha. It's a life of selling out. I'm a living hell, and I intend to keep my devil out."

I walk past the rooms ready to be made up. In the distance I hear lovers making love on squeaky beds, or tricks turned for pennies. Two runaways share their dreams, a single mother awaits her welfare, a mental patient tries not to take his own life.

A maid for the hotel passes me by with clean sheets. She speaks in Polish.

I understand. She says, "This is life."

You need to be lost in order to find your way.

Emperors Club VIP, an "international escort service" operating as an illegal prostitution ring. Soon after, photos of his escort Ashley Dupré emerge. | **03.12.2008** Eliot Spitzer announces his resignation, delivering a public apology with his wife Silda by his side. | **03.19.2008** To mark the fifth anniversary of the US-led war in Iraq, President Bush gives a speech standing behind his decision to invade Iraq. | **03.23.2008** The death toll of US soldiers in Iraq reaches 4,000. | **04.04.2008** Beyoncé Knowles and Jay-Z wed. | **04.2008** Miley Cyrus is photographed topless by Annie Leibovitz for *Vanity Fair*, sparking controversy about teenage nudity. | **04.20.2008** Danica Patrick wins the Indy Japan 300 and becomes the first woman in history to win an Indy Car race. | **05.05.2008** US spending in Iraq is up to $5,000 per second. | **06.06.2008** A Fox News anchor refers to Barack and Michelle Obama's fist-bump as a "terrorist fist jab." | **06.07.2008** Hillary Clinton endorses Barack Obama as Democratic presidential nominee. | **06.11.2008** Norway legalizes same-sex marriage. | **06.2008** Facebook deletes the accounts of a group of students from the Danish School of Journalism who post pictures of themselves eating a cat that was prepared by a professional chef. The photographs accompany an article discussing the imbalanced treatment of domestic vs. food animals. | **07.2008** Italian *Vogue's* all-black issue hits newsstands. | **07.07.2008** E! reports that Eliot Spitzer escort Ashley Dupré is engaged in talks over a proposed reality show. | **07.12.2008** Angelina Jolie gives birth to twins Knox and Vivienne in France. | **08.08.2008** After months of tabloid stories, former senator John Edwards admits to having an affair with Rielle Hunter, a videographer who worked on his campaign. He denies, however, that he is the father of her child. | **08.23.2008** Democratic presidential nominee Barack Obama announces Delaware senator Joe Biden as his running mate, via text message. | **08.28.2008** Barack Obama accepts the Democratic nomination for president. | **08.29.2008** Republican presidential candidate and Arizona senator John McCain announces Alaska governor Sarah Palin as his running mate. | **09.01.2008** On the opening day of the Republican National Convention, Sarah Palin announces that her unmarried seventeen-year-old daughter, Bristol, is five months pregnant. | **09.1–4.2008** Over 300 people are arrested for protesting the opening of the Republican National Convention in St. Paul, Minnesota. | **09.03.2008** Sarah Palin formally accepts the vice-presidential nomination at the Republican National Convention. A highlight from her speech: "You know what they say is the difference between a hockey mom and a pit bull? Lipstick!" | **09.04.2008** John McCain accepts the Republican nomination for president. | **09.24–25.2008** Sarah Palin is interviewed

NATION BUILDING

Introduction

This series of artworks consider, respond to, and reflect on the immediate crisis of our government in its quest for nation building. I focus on individuals at the center of our involvement in Iraq. The works are based on political content, media images, and the distortions of images for reconsideration. They speak together about America's dominance and the distance and dehumanizing condition of war. Within this context I recall America's own history of gazing at the terrorized body. First and foremost, America's participation in domestic terrorism: the lynching of African Americans. I ask the audience to consider the use of terrorism as part of our own nation-building history.

Death Watch

I created a wallpapered chamber of illustrations representing the hanging of Saddam Hussein. This black-and-white repeated pattern addresses the over-exposure and unedited saturation of horror and death within our daily lives.

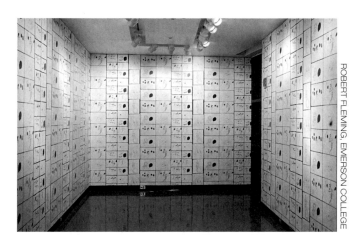

ROBERT FLEMING, EMERSON COLLEGE

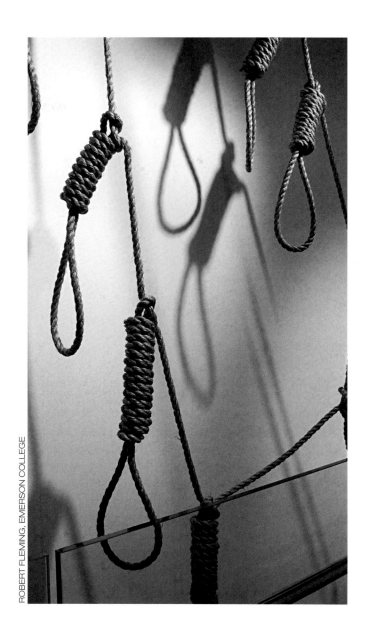

ROBERT FLEMING, EMERSON COLLEGE

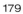

179

ecticut legalizes same-sex marriage. | **11.04.2008** Barack Obama is elected as the first African American

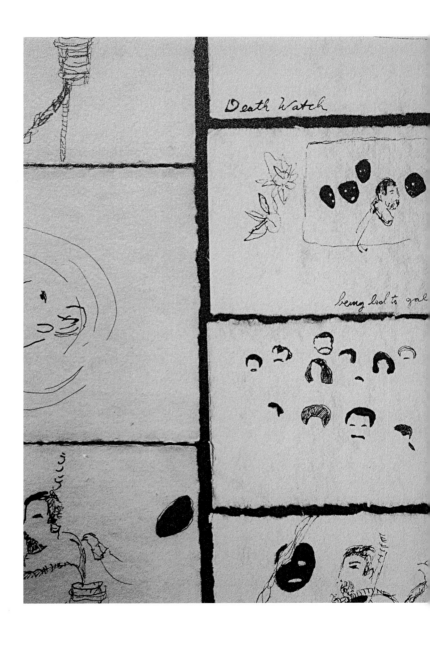

181

sses in California. | **12.01.2008** Barack Obama announces that he will nominate Hillary Clinton for Secretary

Mine Eyes Have Seen the Glory: The Eyes of Condoleezza Rice

In this fourteen-foot wall mural, I use the image of a bomber, substituting the bombs for the eyes of Condoleezza Rice. The use of eyes references Surrealism, which came into prominence with Freud and his interpretation of dreams. It's also relevant that Surrealism was formed by artists who fought or lived through World War I and saw the ravages of mustard gas and the destruction of the landscape. The eyes also invoke what Rice has seen as a child growing up in Birmingham, and her participation in war as an adult. I am interested in identifying the perpetuation of violence. When Martin Luther King was serving a sentence for his civil rights work in April of 1963, he wrote his famous letter from the Birmingham jail. In September, just five months later, he would deliver the Eulogy for the Martyred Children, at the Sixteenth Street Baptist Church. Condoleezza Rice knew those children.

The phrase, "Mine Eyes Have Seen the Glory" recalls the last speech given by King the night before he was assassinated, in which he stated: "I'm not worried about anything. I'm not fearing any man. Mine eyes have seen the glory of the coming of the Lord."

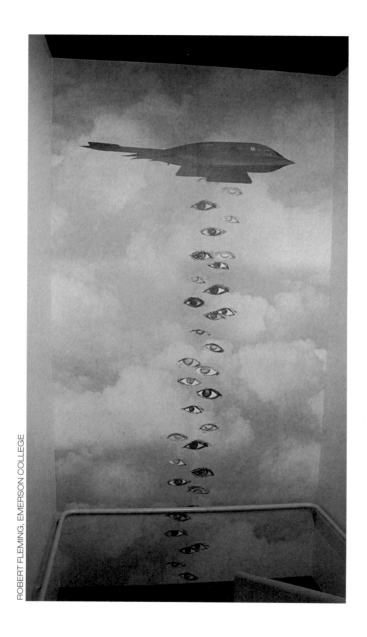

ROBERT FLEMING, EMERSON COLLEGE

wly missing the president's head. | **12.27.2008** Over 70,000 Facebook members hold a "nurse-in" and post

photographs of women breastfeeding in an attempt to change the site's current obscenity laws, which do n

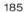

ROBERT FLEMING, EMERSON COLLEGE

low photos of breastfeeding to be displayed. | **12.29.2008** The US Treasury gives auto financing company

Business as Usual

In this installation the gallery is set up as an office where the computers print out the Iraqi and American war casualties and they are filed daily.

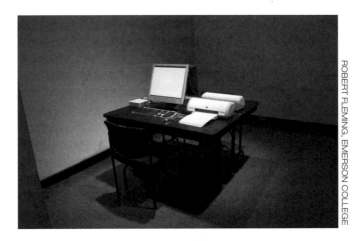

ROBERT FLEMING, EMERSON COLLEGE

Ramon C. Ojeda, 22, Army Specialist, May 01, 2004
Oscar D. Vargas-Medina, 32, Army Staff Sergeant, May 01, 2004
Trevor A. Wine, 22, Army Specialist, May 01, 2004
Joshua S. Ladd, 20, Army National Guard Sergeant, May 01, 2004
Ervin Caradine Jr., 33, Army Specialist, May 02, 2004
Jeremy L. Drexler, 23, Army Private, May 02, 2004
Todd E. Nunes, 29, Army Staff Sergeant, May 02, 2004
John E. Tipton, 32, Army Captain, May 02, 2004
Michael C. Anderson, 36, Naval Reserve Petty Officer 2nd Class, May 02, 2004
Trace W. Dossett, 37, Naval Reserve Petty Officer 2nd Class, May 02, 2004
Ronald A. Ginther, 37, Naval Reserve Petty Officer 3rd Class, May 02, 2004
Robert B. Jenkins, 35, Naval Reserve Petty Officer 2nd Class, May 02, 2004
Scott R. Mchugh, 33, Naval Reserve Petty Officer 2nd Class, May 02, 2004
Christopher J. Kenny, 32, Army 1st Lieutenant, May 03, 2004
Lyndon A. Marcus Jr., 21, Army Private 1st Class, May 03, 2004
Erickson H. Petty, 28, Army Staff Sergeant, May 03, 2004
Marvin R. Sprayberry III, 24, Army Sergeant, May 03, 2004
Gregory L. Wahl, 30, Army Sergeant, May 03, 2004
Ronald E. Baum, 38, Marine Gunnery Sergeant, May 03, 2004
Jesse R. Buryj, 21, Army Private 1st Class, May 05, 2004

ROBERT FLEMING, EMERSON COLLEGE

549 is forced to land in the Hudson River. All 150 passengers and five crew members survive, in a landing hailed

5/23/2008	Muqadam Abdul-Jabbar
5/25/2008	Ali Hashim / Ali Hashem
5/25/2008	Jason F. Dene
5/25/2008	Blake W. Evans
5/25/2008	Frank J. Gasper
5/28/2008	Son of dead man
5/30/2008	Ali Kadhim Salman / Kazim Salman Ali
5/30/2008	Christian S. Cotner
5/31/2008	Ahmed Foad
5/31/2008	Khalil Ibrahim / Khalil Ibrahim al-Jazzaa
6/1/2008	Christopher D. McCarthy
6/1/2008	Justin R. Mixon
6/1/2008	Son of dead woman
6/2/2008	Faris Younis / Fares Younes Abdul Rahman
6/2/2008	Sayf-al-Din Baqi Abbas
6/3/2008	Dalshad Abdullah
6/3/2008	Dhafir Ghanim / Dhafir Al-Ani
6/3/2008	Quincy J. Green
6/3/2008	Hasan al-Laythi
6/3/2008	Mustafa Zuheir
6/3/2008	Naseh Moussa
6/3/2008	Joshua E. Waltenbaugh
6/4/2008	Shane P. Duffy
6/4/2008	Jonathan D. A. Emard
6/4/2008	Cody R. Legg
6/4/2008	Nephew of Nadhem Tayeh
6/4/2008	Rahim al-Bidhani
6/4/2008	Rasoul Abed Al-Halbous
6/4/2008	Son of Rahim al-Bidhani
6/6/2008	Children of Awakening Council commander
6/6/2008	Wife of Awakening Council commander
6/7/2008	David R. Hurst
6/8/2008	Tyler E. Pickett
6/9/2008	Abdulnoor Mohammed Noor Al-Tahhan
6/9/2008	Thomas F. Duncan III

6/10/2008	Ali Hussein Ali
6/10/2008	Steve A. McCoy
6/11/2008	Eugene D. M. Kanakaole
6/11/2008	Javier Perales Jr.
6/11/2008	Gerard M. Reed
6/11/2008	Son of dead woman
6/11/2008	Kelly E. C. Watters
6/12/2008	John D. Aragon
6/13/2008	Ahmed Tema / Ahmed Tumeh Khalaf
6/13/2008	Greg Loomis
6/13/2008	Son of Ahmed Tema
6/14/2008	Brother of dead policeman
6/15/2008	Adel Hussein al-Wagaa / Adel al-Waqa'
6/15/2008	Daughter of dead couple
6/15/2008	Waleed Saad Al-Mawla / Walid Saad Allah al-Mouli
6/15/2008	Wife of dead man
6/16/2008	Jason N. Cox
6/17/2008	Ahmad, son of Marwan Hazim
6/17/2008	Ali Haydar al-Azzawi
6/17/2008	Child of Muhammad ?
6/17/2008	Karam / Akram Marwan, son of Marwan Hazim
6/17/2008	Marwin Hazim
6/17/2008	Mohammed Wali / Mohammed Wali Mryoush
6/17/2008	Mohieldin Abdul-Hameed
6/17/2008	Munyee Al Deen Abdul Hameed
6/17/2008	Radwan, son of Marwan Hazim
6/17/2008	Saleh Mehdi Kuneihar / Salih Mahdi al-Shimari
6/17/2008	Wife of Muhhamad ?
6/18/2008	Mohammad Quaism
6/18/2008	Sadiq Ismail
6/18/2008	Mahomoud al-Dwadi
6/19/2008	David Arturo Olinger
6/20/2008	Du Hai Tran
6/21/2008	Ali Zaid Owayid al-Shimmari
6/21/2008	Ammar al-Shimmari

189

ates. | **01.21.2009** Hillary Rodham Clinton is confirmed in the Senate and takes her oath as Secretary of

State. | **01.22.2009** President Obama signs an order to shut down Guantanamo Bay detention center. | **01.26.2009** Single mom Nadya Suleman is dubbed "the Octomom" after giving birth to eight children. | **02.09.2009** Eluana Englaro, a woman in the center of the right-to-die controversy in Italy, dies shortly after the Supreme Court rules to have her feeding tube removed. Englaro was thirty-eight years old and had been in a coma since 1992, following a car accident. | **02.19.2009** A domestic violence photograph is leaked from the LAPD and released by TMZ. The photograph shows the battered pop star Rihanna in the hours after the Grammy Awards. | **02.27.2009** President Obama announces his intention to withdraw most American troops out of Iraq by August 31, 2010. | **03.2009** The Obama administration discontinues use of the term "War on Terror" in favor of "Overseas Contingency Operations." | **03.05.2009** Chris Brown is charged with assaulting fellow pop star, Rihanna. | **03.18.2009** New Mexico repeals the death penalty. | **03.20.2009** Michelle Obama breaks ground for the White House's first organic vegetable garden as part of her campaign to end childhood obesity. | **04.01.2009** Sweden legalizes same-sex marriage. | **04.03.2009** Iowa legalizes same-sex marriage. | **04.06.2009** Lindsay Lohan tells E! News that she and girlfriend Samantha Ronson have broken up. | **04.05.2009** North Korea launches a long-range rocket over the Pacific Ocean. | **04.07.2009** Vermont legalizes same-sex marriage. | **04.13.2009** Mel Gibson's wife Robyn Moore files for divorce after twenty-eight years of marriage amid rumors of Gibson's infidelity. | **04.26.2009** The US declares Swine Flu a public health emergency. | **05.31.2009** Dr. George Tiller is shot and killed by anti-abortion activist Scott Roeder in the foyer of his church. | **06.01.2009** Dick Cheney speaks out in favor of same-sex marriage. | **06.03.2009** New Hampshire legalizes same-sex marriage. | **06.17.2009** President Obama signs an order allowing the same-sex partners of federal employees to receive benefits. | **06.18–24.2009** Republican South Carolina governor Mark Sanford disappears for six days and later resurfaces to admit to having an extramarital affair in Argentina. | **06.25.2009** Farrah Fawcett dies of cancer at the age of sixty-two. | **06.25.2009** Michael Jackson dies unexpectedly at the age of fifty. Fans around the world mourn the loss of the King of Pop. | **06.28.2009** The fortieth anniversary of the Stonewall Rebellion, which is cited as the beginning of the gay liberation movement, is celebrated. | **06.30.2009** After an almost eight month battle, Democrat Al Franken wins the US senate seat for Minnesota. | **06.30.2009** US troops complete their withdrawal from Iraqi cities and transfer control to Iraqi troops. Iraqi prime minister Nouri al-Maliki declares a "National Sovereignty Day." | **07.02.2009** New Delhi's highest cou

IMPULSE TO SUCK

Introduction

On March 10, 2009, I traveled to Albany, New York, to hear a speech from Governor Eliot Spitzer on reproductive health. There were hundreds of concerned citizens, who had also traveled from throughout New York State, to hear what promised to be a strong position by the governor on women's rights. Instead, the speech was mysteriously delayed. We waited and waited. Hours later, Spitzer finally appeared. National media was present—tons of it—obviously not there for a speech on reproductive health. Instead, Spitzer spoke publicly about a private indiscretion. He apologized for having sex with a prostitute, while his supportive, devastated wife stood beside him.

This political moment was in many ways very familiar. We have witnessed other politicians in similar moments in recent times. With this one, I became especially interested in the performance of the apology, and in this case, the media's fixation on Spitzer's frown, and the emotional, starring role of his wife, Silda. Looking at the psychodrama of a political leader, I'm also interested in Spitzer as a son—an immigrant's son—and in the imagined scenarios around his public confession.

192

Alaska. | **07.16.2009** African American Harvard scholar Henry Louis Gates is arrested by a Caucasian poli

IMPULSE TO SUCK

Eliot

Before you vote for me, I would like for you to consider your relationship to lust and commitment, or commitment and lust, or the separation of lust and state, or sex and state. I am an undiscovered self, and in voting for me you will be participating in my life as a mirror or journey, our mythic voyage—the soul's search for meaning. I ask you to join me in the soul's quest for meaning. The yearning is my campaign promise to you. Let me give you the gift of rigorous passion thrust into the political discourse. I am your candidate. Vote for me.

You will see the woman, the mother of my children, and see her face of fear, of sadness. This is a campaign promise, the eyes of a frightened child, battered in all her feminine grace and glory. You may look at her feminine masochism as my inverted sadism. My wife before your very eyes will become numb and in shock for your own pleasure. I will give you her agony in a way you haven't seen since the grief of Jackie.

Chorus
Because I do not know him is not to know him in me.
Because I do not know him is not to say I do not know
his heart and head.

Eliot

For our purposes here this evening, we see the scandal disclosed as a national narrative open for interpretation—an invitation to intimacy. Consider the projection of a nation onto a man's fall from grace as metaphor, as an archetypal melodrama.

Instead of looking at his, my, sexual hubris in moral terms—as a flaw, a weakness, a compulsion—let me invite you into my soul-searching: I am a forty-eight-year-old male who is connecting to my undeveloped twenty-two-year-old feminine principle. My/his/our/feminine can be bought and paid for. My feminine, our feminine, together as one, is not protected, is illegal. My feminine spirit is trafficked *and* I created laws, laws broken, made by myself for myself, to protect me against the sucking princess. My feminine is not mother or maternal, but is temptress. My feminine is illegal, full of shame, anxiety, repression, and guilt. My femininity is not provided for, is not secure. My secret feminine principle is behind closed doors with black socks on, naughty and dirty. My girl/self/feminine soul will only perform for the money, will only perform for the money. My feminine spirit is only able to come out when I have worked for her, to take the edge off, as a way to protect myself from the taboo of desiring my mother, the taboo of desiring my wife as mother—to remind me not to desire mother. Let me

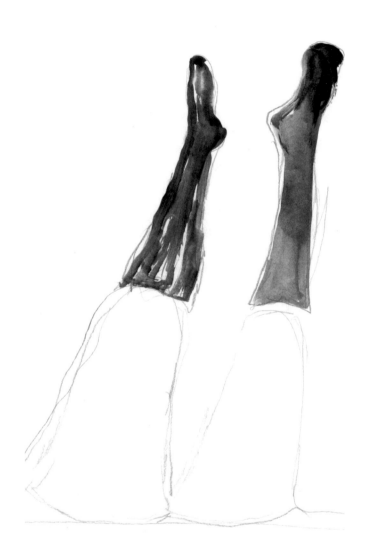

...ersy. To resolve the situation, the president invites both men to the White House for a beer. | **07.23.2009** After

have my hot-tempered puss, my piece of ass, my twat. Let her suck, like I suck at my mother's breast, like I sucked my thumb until I was seven.

My creativity focused on awakening life from my male loin. Give me womb envy, with my penis as sword, as hari-kari, a weapon of my own self-destruction.

The night before Valentine's Day, oh sweet ones, as you waited with your chocolates and fancy boxes, with red panties and perfumed poetry, my Godiva waits for me on the night predestined to be discovered with my escort, my paid sexual companion. Ashley, as in *Gone with the Wind*, Scarlet O'Hara's *secret* Ashley, my *secret* Ashley. Or, if you prefer, her escort company name, Kristin, as in Christian. Kristin, as in Christ. My very own Christ child. Valentine's eve was the night I had to have her, take the night train, and travel to me. In the hotel, The Mayflower, named after our Pilgrim's pride. As the nation's capital sleeps my lady-in-waiting, my pussy delivered. I didn't pay for her to come. As Clinton had his tool sucked, I would too. As Jefferson, as Kennedy, as Roosevelt, as Eisenhower, as Truman.

Sometimes I pretended I was everyman. I was a trucker with my gal at the rest stop. Or a traveling salesman, going door-to-door with my gal. I have so much love to give. You got it right: I am the LOV GOV.

We are taught to look at porn before we bomb. The female anatomy was pinned on the dashboard before

we bombed Cambodia, Iraq. Before Hiroshima, it was looking at pussy that got us through. Pussy, where we all come from—swollen breasts, ready to hold milk. On the eve of Valentine's Day, I was in Buffalo, speaking of higher education, ready to give my report at the State University of Buffalo, with thoughts of the honeymoon suite, with thoughts of my sexual concubine taking the train, choo choo all aboard. Buffalo was my foreplay, my city of arousal, before I traveled to Washington for the evening. My wife was in Washington but instead of asking her to join me I requested Kristin to take the train from New York. Perhaps they would pass each other in the station, or cast their heavy lids and gaze out at the tracks.

After my rendezvous with lips between my legs, I testified in the morning before Congress on the bond crisis, but not before my own James Bond was in crisis. I listened in on Joe Bruno's galloping racehorses. My heart would race for a sucking babe, before I go after Wall Street and the investment firms, I would want to invest my capital with interest in an escape of passion, for the loss of ego in an orgasm. I need a sucking babe. A sucking babe. The world sucks. It all sucks. I just need to keep the edge off.

The state, our Empire State, is a place for the emperor to reign, to be part of the escort service, of the Emperor's Club, emperor of the state, my state becomes a character, a personality, a person of interest, and yes, I have Dad issues. I was exploited by my father for my wit and intelligence. I was to become what he wanted, a person of authority. He transferred onto me his feel-

ings of inadequacy. To compensate for my father's growing up in an anti-Semitic reality, he pushed and pushed, just like Joe Kennedy and the Irish did. I was to solve his problems—and this is where the agreement between father and son was made. My father with his father and your father with his father—I was to prove and be proven for the family. The honor my father never felt, he pushed me, and never ever loved me. I was never loved for just being Eliot, for being kind. I was never loved for feeling.

Let me contribute by studying birds: I want to search for the cerulean warbler nesting along the shores of the Hudson. Or take long walks to know where the rainbow falls in the sky. I could not be me. I never knew me. I was not allowed to experiment, to get lost, to take time off, to pretend. I could not play, fail, not know. I could not cry. I could not let someone else do it. The pressure stayed on—even at the dinner table. I was on my father's schedule to finish his goal for me by the end of his life, to keep the family pride. I am so sorry you suffered, Father. All of your sacrifices, your work, your discipline, you, the son of an Austrian immigrant. The hate our family has endured, the evil our family witnessed, fled, and overcame. I became your everything. I became your day, your payday, your night, your night sweats. I became your dream, your vision. And the twenty-two-year-old girl inside me–whether Ashley or Kristin or Lisa or Mary or Rachel or Connie or Monica or Liz. Where is my dream? Where is my imagination? Where is my passivity? Suck me suck me. Hold my power, my birthright. Let this penis get me caught.

If only I was born a woman. If only all I had was to put the pearls around my slender throat. If only I could marry myself. You voted for me to oversee the pursuit not of life and liberty, but of controlling the uncontrollable. That man is not perfect. And that this man is tempted by Eve. New York is the big apple. Let me bite her. I am leaving the Garden of Eden and seeing myself for the first time.

(This may be spoken by Silda (wife), or Eliot (husband), or in first person by Ashley (whore). The timing and the voice can become slow, hushed, breathy, ecstatic, or pained.)

She's on the train. She's getting her ticket. She's waiting in line. She's at Penn Station. She will try and make the most of it. She would rather be somewhere else. She's getting dressed for him. She's imagining the evening.

She's scheduled for his privacy. She's not one woman, she is all women. She is me, I wish I was her. She gives him her ticket. She packs her bag. She looks out the window. She waits her turn. She is getting closer to him. She gets off the train. She takes the taxi. She goes to the hotel. She walks through the entrance. She takes the elevator. She has been there before. She knows her way. She is still a bit nervous. She is looking in the other direction. She checks her purse. She makes a call. She goes into the elevator. She pushes the number eight. She is alone in the elevator. She looks in the shiny copper.

She walks to 871. She opens the door. She walks in
the room. She takes off her coat. She draws the cur-
tains. She turns on the TV. She prepares her body.
She makes her toilette. She looks in the mirror. She
waits. She is hesitant. She is anxious. She waits for
him, she waits for my husband. No expectation, no
obligation. Let me connect with her. She makes me
feel ugly.

Let me connect with her.

Silda
Let the focus be on me. But my me has been you,
being me. Has been loving you. My center is extended
out of me. So I float out to others. As the extended air.
Of breath. This sky blue jacket. The color of *la mer*.
Color of Mother Mary, of Virgin birth. Of breath. Of
sky. Breathe me in. If I am to be in you it's the way I
have been taught to love. To extend out. Let me enter
you that way. Overwhelm you in loving you. It is the
way I fuck you.

I was in you when you were with her. With the others,
the affairs. The indiscretions, the moods, the empty
beds. The salacious scandal. The scandal is mine. I
cooperated in the traditional values of women, of lov-
ing wives. I kneel, I beg. See me love. No one can love
like I love. No one can love like I love you. Let me
love and love and love. See me love the unlovable. Let
me hear you. It's music to my ears; my heart warms
when you say, "How can she love him?" "How can she
stay with him?" My compulsion is in my loving. My

indiscretion was to focus on our children, our family, on you through you. You are my center. Grieving for a life that never was. I retreated so you could fulfill the life you dreamed. In the same way that you *gave in* to your compulsion I *gave in* to you. In the same way you could not help yourself, I could not help myself. You are in love with a girl named COMPULSION. The compulsion, the impulse became your knight, your hero, your true romance, not her but the thrill, personified as so strong, you could depend on the strong shoulder of your impulse, you could lean on this big daddy love. Giving in to your desire allows you to be soft, subtle, passive, feminine, can't help yourself, give into, accepting just like a woman.

Resign. Resigned. Don't resign.

Give it all up for him. Let me surrender to your fall from grace. Let me resign to the distress. Let them see me sad, sadder. No one is as sad as me.

Chorus
No one is as sad as you. You are the saddest of them all. You are the saddest woman in the land. The sad empress. Sad empress.

Silda
And I love you despite my deep sadness. My sadness displays my love with grandeur. I plead with you, husband, my partner, do not despair. Do not resign. Let me resign in my surrender in my love for you. Let me be the one. Let me be the strong one for both of us.

Let me show you how I am stronger than you. Let me be sad for everyone.

Eliot

I will be stoic in my apology with you by my side. I will stand up as a man and confess. I hurt her. I let you down. I am a sleaze. I am your worst nightmare. I don't deserve your love. I am a cheap shot. Hate me. If you love me then hate me. Should my apology be short and sweet? How do you want my apology? Shall I cry and be unbearable. Should my whole family stand with me? Get me the research on apologies. I want to see the stats on sorries. Bring me *Apologies for Dummies.* Get me the leading academic consensus on the proper language and checklist for the apology. Get me all academic articles in leading academic journals on the history, the theory of *sorry.* Get me the calculated risks. If I should be gender neutral, if I should be multicultural and bilingual. Shall we have the apology in Braille? I want the apology signed. No one is to be left out. Everyone is to feel included. Let me look at the sorry of Clinton. Let me look at the sorry of Nixon. Or would you prefer the sorry of Michael Richards, the sorry of Mel Gibson, the sorry of Craig, of McGreevy? You choose the sorry. You decide how I should be sorry.

We can go back farther if you wish—to Plato's apology, or read the essay on the apology by Shaw.

Atone. Let me atone—be at one with me. At some point I need both pity and mercy. Maybe if you give

me mercy I will be able to feel mercy for others. Why do I still want to fuck my brains out or be sucked and cuddled? I want my mother's tit to suckle, her teat when the stress is too much, a dressed up doll to undress. Confession, anoint me with high holy days. Finally I have a reason for religion. Sin is sexy, sin is sin is naughty as nice, nice is not sin and nice is mommy and be nice and sin walk in me mommy with my pee pee and be horrified as my masculinity makes you shudder makes you wince as I long for my self pleasure. Secret, secret spaces: the skin, the pubescent light of the perineum, the hymen, the vaginal cavity of secret desire. My tool to be sucked, my rock man pushed and pulled. Lick me like a mother licks her fawn, a tiger, her cubs, her underbelly. Mother whore Madonna whore.

Dress like the hooker.

Silda
Let me dress like the hooker. Let me be a hooker. Let me be a first lady madam hooker. Let me get the cuffs. Let me strap it on. Let me tell you when. Let me take it slow. Let me punch the clock. Let me suck the cock good and hard. Let me don't give a shit. Let me have a bitter taste. Let me swallow.

Eliot
You are my approval rating. You are the reporter to take notes.

Silda
My children deserve better. My children . . .

204

Eliot
But if my daughter whored I'd disown her. She is
my property. She is my blood. Our daughter wasn't
brought up like that. Next, let me humiliate myself
fully in public. The mother or my wife is walking in
with me to give the apology. My wife is standing next
to me. My wife as father. Hold her head high.

Silda
Hold head high. I will hold my head high as you apol-
ogize. Stoic. Like the head of the penis. A new sin-
ner arrived in town. The power of pussy. It is pussy's
fault. It is all pussy's fault. It's the power of pussy.

Maybe if I had a makeover like Ivanna he would
fuck me like a whore. Maybe if I had a makeover
and shaved my pussy he would fuck me like he had
to have me. Maybe if I didn't care he would desire
me. Maybe if I wasn't so smart, so good, so devoted he
wouldn't treat me like this. I need to stand here for
my daughters. That is what the New Jersey governor
and Dena McGreevy did. Let me teach my daughters,
just like Chelsea was taught, the power of pity, the
power of sadness, the power of goodness. The power of
pity, when really it's the power of pussy.

I know he is an addict. Then I love the addict. I love
the addict. I want to go shopping. All I want to do is
go to sleep. I want to go shopping, then sleep. Shop.
Sleep. Shop. What can I buy today?

Chorus
One lick and you suck for life.

I don't need Viagra to stand by my man. I don't need to be stroked to be strong to stand up next to my husband. I don't need to be teased or coaxed to stand straight in my support for my husband. I was taught to love him as a little boy as he confesses to his wrongdoing. This is my mother love. He hates my mother love. Because he knows the children come first. He hates his mother. Look at my face, my face you've hurt. In my powder blue the color of baby blue. Standing by god, the authority the power. I am here to give him support, and to support my starring role. Controlling the uncontrollable.

206

(Invite volunteers to write on chalkboard.)

Let me put it this way, in an organized system, in a numerical reasoning:

1. He's a schmuck; too bad for the wife and all of his governmental duties.
2. He built his image on his false self.
3. He built his career going after people like his secret self.
4. He thinks he's above the law.
5. He doesn't care about anyone but himself.
6. His life is no longer private; now it's a state affair.
7. He deserves clemency.
8. He deserves mercy.
9. He should be recognized as having an addiction.

10. He is in denial about destroying his and others' lives.
11. He went after those with an addiction while participating in the addiction.
12. He's a closet addict.

Okay, there are a few things on my to-do list for my new campaign, my new reality show, my new memoir called *Love Means Having to Say You're Sorry*.

I will need a mascot, a talisman, something very small and furry, a little kitty. A Beanie Baby. I will star in my own musical, called *Women, Wine, and Roses*. I will be on *Oprah* in a segment called "From Pain to Compassion." I will be on *Larry King* and talk about how I got through it. I will have a nervous breakdown when I am ready. I will cry alone or for the camera. I will look in the mirror and say, "Where did I go wrong?" I will try to start the day with a better attitude. I will dust off my résumé. I will start wearing yellow more. I will give up coffee. I will fast on nothing but lemon and water and cayenne pepper. I will buy myself flowers and create an altar with all things turquoise. I will see the Seven Wonders of the World. I will never look at my photo album. I no longer have the compulsion to remember. I will offer the following advice when I start my own company based on Weight Watchers called Keep the Focus on Me: Counting Your Emotional Baggage Caloric Intake.

Don't be understanding like a parent. Don't focus on him. Don't be accepting like a therapist. Don't wait for a change. Get involved in as many activities as

possible. Keep your calendar full. Don't rearrange life. Don't get hooked on failures. Don't move closer. Build a separate life. Take a vacation. Don't be accepting. Maintain distance. Back away as far as you comfortably can. Don't solve his problems. Change work. Don't accept the ambivalence. Don't give away your feelings. Respond don't react. First things first. Keep it simple. Live and let live. One day at a time. When the sun is down pass it around.

Let go and let god. Let it begin with me. Think. When you change the way you look at things the things you look at change.

Eliot

I am still with you, as your husband and a father and the potential of us. I am still here no matter what I have done to you to destroy your trust. The commitment—what commitment? Commitment scares me. You are a woman, a person of detachment, a will of determined optimism. I never felt I satisfied you. I know this because of my mother—my mother was never satisfied with me. I was not as sweet as my brother in my mother's eyes. The agony—don't look at me with pity or understanding or contempt—perplexed me. I had everything but felt nothing. Don't look at me that way! Hate me. What do I have to do to get you to hate me? Don't look at me with understanding. That is the look that I want to kill. I get more in fifteen minutes with her than I do in a year with you. When it came to us, I did what I wanted rather than what you wanted because I was afraid of disappointing you and giving all of myself to you. I had affairs,

indiscretions, relationships to protect my secret self. I neglected you because I needed something. I needed something, but my major relationship was with the dissatisfaction. I never wanted to satisfy my mother; that was my father's duty. I never knew my father. Our dinner conversations were a series of cross-examinations, evidence gathering. The talking revolved around him—what he got out of someone, got over on someone, someone was always out to get you. It isn't that I wanted to please my father but I was in fear of losing his love if I displeased him.

What sweeter revenge—Mother, Father—than to punish both of you with my failed life. It is my sweetest joy. My perverse self-destruction is all about my need, my patient repressed need to punish, and finally express how much hate and misery I have for you. Finally the suffering is out in the open. I lived my father's life—I became the authority. I could get into the law firms that did not employ Jews. Remember, our money is still spoken of as Jew money, and it couldn't get you into the country clubs, the board rooms, the Ivy League, the political insiders. But I did it, Dad. I did it for you. I wanted to give you the respect you never felt you had. I could have been president. The first Jewish president. You pushed me and pushed me, just like Joe did to Jack did to Bobby did to Teddy. This wasn't Chappaquiddick, or was it? I never was enough for you. Did you want a hero? Did you want an assassination? Oh, I took care of that. Did you want a funeral—everyone crying, the black veil, the riderless horse, the procession, the eternal flame? Oh, where is Gloria Swanson? Where

is Marilyn? Where is Peter Lawford? I gave you character assassination instead.

Don't hate me because I couldn't give you back your father's Austria, take away the war, take away the Nazis. I wasn't there for Himmler. I wasn't there for Hitler. I wasn't there in Austria when Grandpa left. I tried to make it up for you. To give you the glory so that for a moment you might feel accepted, wanted, cherished. I know you deserved to have been able to accomplish more than me. I know that if you had had the advantages I had you would have accomplished more. You let me know this every day, every waking moment, that everything I did or accomplished was earned by you paving the way. I'm not giving you what you wanted most, a successful son.

We drifted farther apart because I was no longer capable of correcting the evil done to you. It is impossible to rewrite a past, and when I understood I came to understand our underlying dynamic and it horrified me.

It is time for me to look at me. Women, roses, and wine. You are my valentine. Round is the ring that has no end. Hold her in my arms not knowing your name. Love for my wife, love for my other life. I offer you my heart, broken and weary. Kiss me, hold me, I am teary. I select you from among the rest. The reason, simply I need to hurt you best. Be my valentine.

Oh, come with me as I walk the cool nights along the river's shore, and look for sailors and shore girls. Wait

for me as I cast my own shadow onto others. What is not made conscious will continue to haunt our lives.

My desire for understanding, for what I am doing, I do not understand. For I am not practicing what I would like to do. But I am doing the very thing I hate. But if I am doing the very thing I do not wish, I am no longer the one doing it. I am someone else, the multiplicity of me, the shadow within.

Which way I go, which way I do. Hell dwells in order to imagine heaven.

Lord, take this gorgeous temptation away but don't take it away too quickly.

Lord, everything you make is part of you. Make this gorgeous temptation stay! Don't leave me too abruptly. For where will that part of me go? My longing and yearning, my desperation, which gives me purpose in this meaningless world.

Unzip these trousers and let my bottle be warmed. Take my bottle in both palms. I will look down on you drinking me with hunger and a firm grip.

And I will stroke your face and moan. Take my bottle. Suck it till you get air.

I will bring you to my shoulder and pat your back, as you burp the last few bubbles. The taste of mother's penis bottle chokes you. Pushing it in your sweet want-ing mouth. Swallow for mother. Feeding on demand,

crashes his Escalade outside of his Florida home. The accident sparks tabloid rumors of trouble in the athlete's

marriage. | **12.01.2009** President Obama sends 30,000 more troops into Afghanistan, pledging to remove them

loving on demand. Satisfy my hunger. And the sweet white warm cream rushes to your tummy, digested. I am in you now. You eat me. Eat me. I pass through your system. I am in your kidney, your heart, your liver, your spleen. I pass through your coiled miles of digestion til you pee. Til you poo me out. Because I am worth nothing but shit, a little shitz. A little spitz.

Ashley
Since I am your husband's sex worker, you will prefer to consider me abused in order to accept my occupation. Let's begin then: I was abused, traumatized by my stepfather. I grew up upper-middle class. For a moment you don't feel safe. You want to believe that your daughters can't grow up to be me. You want to believe that your daughters are not me. You want to believe that you don't barter fuck.

213

Call me a whore, a pussy, a cunt, a ho. Call me a dog, a slut, a slit, a stanky. Call me beaver pelt, skunk, and cheese. Call me a bitch, a hag, a scone, and a rag. Call me misses, madam, hat rack, come over here now. Call me swinger, swagger, Kool Aid Joe. Call me hot, cold, or a dominatrix. Call me mommy, daddy, or let me give you a spanking. Let me be the man. Get on top and let you be the baby. Let me whimper, go slow, and swallow. Let me take your shit, be so happy to see you. Let me look you in the eye and you will always remember me while you forget me. Let me be your hooker your candy store your drive-through lunch.

Call me a bitch, whore, a slut, skanky, a ho, a cunt. Call me a witch, a hag, a crone, a nut job. Call me

easy, a home wrecker, a shameless hussy. Call me tomorrow, or when you have to have me. When you can't face her. Call me shit for short. Call me Jesus as I swallow. Call me Maria, Mary Magdelene. Your mother did it too. Call me pink. Call me pussy. And I'll purr til the time is up. You are my wally, my wallet. You're my sugar daddy.

I am qualified for his desire. When we see a client fall, when we see a human fall, we want to be the voyeur to peek in at what was his kink. But that is society's kinky: to discover the man in power, to legislate the state daddy's need for intimacy. Like some colonial drawbridge to self-awareness—watching him being caught, watching him wanting me, watching all the sordid nasty details. I feel so so good. My inner beauty performing a song of seduction. I give him the distance he needs. The money provides the distance. For a man loves by being a provider. The transaction is necessary for the release.

What would you say if I do it because I like it? I do it because I can? What would you say if I said I do it because I'm good at it and you're not? Since the beginning of time society has tried to figure out how to contain our type. The loose woman. We mostly come from poverty and lack of opportunity. But some of us have a choice; we slum it, just like when you see artists on trust funds living in tenement apartments to give their creativity placement. We call it recreational whoring, weekend HOing. It is about choice. But mostly it is about male power over female bodies. I was lured in by a cruising pimp looking for chicken. It is a lucrative exploitation. Then the

real tricks begin. The governor's daughters aren't going to the private school and then to Princeton to get a degree in the brothel. So it is a matter of class and economics. But it is also about my needs. Yes, the pimp befriends the girl and the process begins. Is the state responsible? The governor would have to answer. Use your legislative power to decriminalize prostitution. Instead of apologizing, stepping down, step up as a john. It is time to stop legislating the female body. We need a new value for prostitution and necessary services rendered. All women are colonized to some extent.

I am India. I am the Philippines. I am Berlin. I am Hawaii. I am Afghanistan. I am the West Bank. I am Iraq. I am the gift of freedom. I am capitalism. I am the proof that soldiers are dying so women will remove their veils.

Governor, we need to take the sexual revolution another step further. Instead of the prohibition of prostitution which only creates bathtub gin and back-alley rape, we need sex and the pursuit of happiness, liberty for all. We need to open up and no longer condemn a population for paid desire. The state should not enforce morality. We should include in the state university system a degree in the loving arts. A certificate of loving touch. And offer scholarships and assistance to sex workers like we do for returning soldiers from Iraq. In time working girls will be taken seriously, accredited, and sometime in the future, when I receive my PhD in Make Love Not War and I have a patient in need, on the doorknob a sign will read THE DOCTOR IS IN.

Full Discloser or Truth Hurts

(Eliot wakes his wife, Silda, in the middle of the night to alert her of the morning breaking news of being investigated for criminal charges for paid services from a prostitute. This is the first time that Silda learns of it.)

(Eliot enters the bedroom, stands at the door, and speaks out to Silda in a matter of fact, firm voice.)

Eliot
Honey, sorry to wake you up. Hey, I need to tell you I was caught going to an escort service and the *Times* will be breaking the story in tomorrow's paper. I just thought you would like to know. I am really sorry about this. I'm sure you already knew, well, you should have known if you didn't know. Get some rest. It is going to be a media mess for me tomorrow. And you should try to look your best for the press conference.

(Silda sits up in bed. Waking up as if from a dream and turns on the light. Eliot exits and Silda pulls herself together talking, to herself.)

Silda
Disguised as truth, your misogyny needs some attending to.

Tonight you wake me as the dawn is breaking, some breaking news to tell me of your feminine, emotional splitting, in the middle of darkness. I'm made captive by your selective disclosure disorder, an urge that is

216

complicated as are all selective disorders. Perhaps when you were feeling out of control or feeling you were losing yourself in the feminine, losing yourself in woman losing yourself in mother losing yourself in me from the potential emotional weight and you were not with me when you were revealing yourself but with her, for you were being faithful to your emotional infidelity. The trouble is I knew all along but I wasn't prepared for your cruelty, to be told at the vulnerable part of the night when my gender is vulnerable to the dangers of the night. I feel attacked not able to defend myself from you forcing yourself on me with your exhibitionism, your public potency. I can't breathe or catch my breath strangled in your come-clean-truth, your apology. Time to man up so you can woman me down with your public discourse, your lovemaking, a night split shift, an organizational sexual system of surround sound. Sex serves as a management filter, a platform to immerse la pièce de résistance, le grande disclosure of not losing yourself. You won't lose yourself in me, in mother, to free your conscience of where you would rather be on the eve of Valentine's Day.

I hope you had a good time. I forgot to tell you that when you told me I looked sad, moments later tears fell from your eyes. Who is sad? Yes, I'm tender, gentle, patient. No one loves like I do. No one loves like I do. Please don't prosecute my heart as criminal intent (activity, complicity). You are doing a good job at pushing me away. Well that's taken care of.

(Lights out)

Eliot and Silda go to couples therapy

Eliot

I know this is about us and our relationship as husband and wife, but I would like to talk about my issues. My issue is about the separation after, or rather the way I feel after I leave someone, leave my paid sexual companion: the feeling, the depression, the abandonment, instead of feeling relieved, happy about having a good time. I am not in the present but in a state of *missing*.

Silda

I thought this was about us? I have to sit here and hear how my husband is depressed after his hooker leaves? How much do I have to endure?

Therapist

How much do you want to endure?

Eliot

I suppose it is unrealistic of me. I am trying to feel, Silda. Feel. Feel. I am trying to feel. I am asking myself where this feeling is coming from.

Silda

Coming from?

Eliot

Am I overwhelmed by my responsibility?

Silda

Was overwhelmed, not *am* overwhelmed.

Eliot
What?

Silda
It isn't *am* I overwhelmed—for you no longer have the responsibility. It is *was* I overwhelmed by my responsibility.

Eliot
Grammar—that is all you can point out? Why don't you turn on spell-check, Silda!

Silda
It is a detail that is worth pointing out.

Eliot
Here she goes with the details. I am opening up my soul. I am trying so hard to open up. Governors of New York don't have degrees in English literature.

Silda
Details? You're out of a job.

Therapist (*to Eliot*)
Let's go back to the feeling of being overwhelmed. When did this feeling start?

Eliot
We've been through all of this before. Is it from my father and the tremendous responsibility he placed on me, or the sadness of not being worthy?

Therapist
So you need reassurance?

Silda
I think the girls and I need some reassurance.

Therapist
I was speaking to Eliot. Now, I asked you to recall what animals were coming up in your dreams—

Silda
I dreamed of a walrus.

Eliot
I dreamed of a naked mole rat.

220 **Silda**
I dreamed I was pregnant but I wasn't with my husband; I was with David Paterson. So I was still able to be the first lady.

Eliot
I am sure it could be arranged. I feel so lonely. I have always felt lonely. When I am working, the loneliness is on hold; when I stop working the hurt begins. Sometimes it comes on so strong, like a tornado. Hello hurt, hello pain, hello itch. I try not to scratch, but I got to itch. All I want is to escape my brain, to get away from the scratch like I am jonesing. I need a happy ending. It's not about you. I know you want it to be about you so bad. It isn't. This is me. This is who I am.

Baby, I never wanted to hurt you. I never wanted to hurt you.

(*Eliot is alone now, it is night and a full moon is out.*)

I remember as a boy. He will do what he pleases. He will look out at the moon. And this time is my time. And no one can find me but you. I will not answer their calls. But play with toys. I won't be home for dinner. I will eat alone. I won't have anything to say to you. But I will look at the moon out my magic window. I will go away and play with my dinosaurs and no one will ever talk to me again. And if they look for me they will never find me. They won't find my secret hiding place, my secret hiding place where I keep myself safe. And if you look you will not find him even when he is right in front of you. I will put scissors in your eyes. And put them in a pot of boiling water.

He won't eat his spinach. He won't share his toys. He won't go outside and play. He will keep his eyes closed. He will keep his mouth shut. He will not go to the toilet. He will not do anything. He has his thumb. His little thumb all for himself. Even though Mum wraps it in mustard cloth. Even though Father smashes his thumb with the book. Even though they laugh and cheer.

He will not do anything. But look out at the moon. Out of his magic window. Where he is loved and soothed for being a boy. And no more expectations.

And one day they all will be sorry. So sorry they ever took his thumb away. And he will suck and suck to his heart's content. As much as he likes and whenever he wants. Wherever he wants. Someday they will be sorry. And he looks out his window, to the man in the moon.

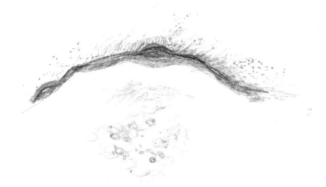

joins Fox News as a contributor. | **02.06.2010** Sarah Palin appears as the keynote speaker at the inaugu

STATE OF NEW YORK
EXECUTIVE CHAMBER
ALBANY 12224

ELIOT SPITZER
GOVERNOR

Good afternoon. Over the past nine years, eight
years as attorney general and one as governor, I've
tried to uphold a vision of progressive politics
that would rebuild New York and create opportunity
for all. We sought to bring real change to New York
and that will continue. Today, I want to briefly
address a private matter. I have acted in a way
that violates my obligations to my family and that
violates my—or any—sense of right and wrong. I
apologize first, and most importantly, to my family.
I apologize to the public, whom I promised better.
I do not believe that politics in the long run is
about individuals. It is about ideas, the public
good and doing what is best for the State of New
York. But I have disappointed and failed to live
up to the standard I expected of myself. I must
now dedicate some time to regain the trust of my
family. I will not be taking questions. Thank you
very much. I will report back to you in short order.
Thank you very much.

conference admitting to several extramarital affairs and confirming his decision to take an indefinite break from golf. | **02.27.2010** An 8.8 magnitude earthquake occurs in Chile, which triggers a tsunami over the Pacific. | **03.07.2010** Kathryn Bigelow becomes the first female director to win an Academy Award for Best Picture for her film, *The Hurt Locker*. | **03.21.2010** Congress passes a landmark health care bill which begins to address the needs of the nation's uninsured. | **03.29.2010** Ricky Martin comes out of the closet. | **04.03.2010** Apple releases the iPad. | **04.14.2010** *People* announces Mel Gibson and Oksana Grigorieva's separation. | **04.20.2010** BP's oil rig Deepwater Horizon explodes, killing eleven people and causing a massive oil spill in the Gulf of Mexico. | **04.23.2010** Arizona governor Jan Brewer signs into law a bill legalizing racial profiling as a method of apprehending illegal immigrants. | **05.2010** Eliot Spitzer escort Ashley Dupré appears on the cover of *Playboy*. | **05.01.2010** The NYPD discover a car bomb in Times Square. Thousands are evacuated; the bomb fails to detonate. | **05.09.2010** The United States celebrates the fiftieth anniversary of the FDA's announcement to approve the birth control pill. | **05.10.2010** Obama names Solicitor General Elena Kagan as the replacement for retiring Justice John Paul Stevens. | **05.17.2010** Portugal legalizes same-sex marriage. | **05.20.2010** A team of scientists at the J. Craig Venter Institute announce the creation of a functional synthetic genome. | **05.20.2010** Five paintings, totaling €100 million, are reported stolen from The Paris Museum of Modern Art. | **05.27.2010** Liza Minnelli appears in *Sex and the City 2*. | **05.28.2010** Two days after sustaining a head injury, Gary Coleman dies after being taken off life support by ex-wife Shannon Price. | **05.29.2010** Shannon Price gives an interview to TMZ defending her decision, stating, "I mean look what happened with Terri Schiavo. I always think of her case, always, when it comes to this." | **06.08.2010** Chris Brown is denied a UK visa due to his 2009 assault charges and postpones his UK tour. | **06.11.2010** Iceland legalizes same-sex marriage. | **06.12.2010** Roman Polanski goes free after the Swiss government refuses to extradite him to the US. | **06.23.2010** Top Afghanistan war commander Stanley McChrystal is fired shortly after giving an interview to *Rolling Stone* in which he harshly criticizes the Obama administration. | **06.23.2010** CNN announces Eliot Spitzer will be joining the network to host a "round-table" discussion program with conservative journalist Kathleen Parker. | **06.27.2010** The first legal same-sex marriage in Iceland takes place. | **06.27.2010** Ten people are arrested and accused of being part of a Russian spy ring, living in the US under false names to penetrate American "policy-making circles." | **06.28.2010** The Supreme Court rules in a 5-4 decision th

THE JACKIE LOOK

Introduction

In "The Jackie Look," I bring Jacqueline Kennedy Onassis back to life, and consider history, style, trauma, femininity, and the demands of being the first lady. Using the structure of a lecture set in the present day, Jackie, one of the most photographed women of her day, contemplates her life in pictures. Along the way she ruminates on Michelle Obama, Caroline Kennedy's run for Senate, and the lasting impact of that fateful day on the grassy knoll in Dallas.

226

son telling his ex girlfriend Oksana Grigorieva, "You look like a f***ing pig in heat, and if you get raped by

THE JACKIE LOOK

1

I have been asked to speak to you today, to the Society of Photographic Education, here in Dallas, in my unique position as the most photographed woman in the world in my time. My talk today will address the looking at me, or rather the looking at or the gazing at trauma, and especially what I am most known for: my witnessing of the assassination of my husband, your president. Simultaneously, the public activity of acquiring and viewing photo documentation of my life, leading up to and away from the trauma. I stand before you as your stress test, your indicator of how much a person can endure in order to monitor and compare and go on with his or her own life. The assassination not only shattered your Jacqueline and my family and our way of life, but our nation, and to some extent the world. It occurred just two blocks away from where I am in my mind no matter where I am.

I would like to share something with you. Before, this subject would have given me much anguish, but with the recent historical and family events, and a new

presidency, I feel that I can finally move to a workable emotion and solution. So please be patient with me for instead of anguish, it is with great trepidation that I have agreed to speak to you about my reflections of being photographed, my memories and reactions of my contributions to the field of stylizing trauma, my contributions to grace under great emotional shattering and not breaking down for the public. And I don't intend to start now.

With Jack's death, the government was not to be trusted, the establishment challenged, the male authority figures who were trusted were routinely assassinated. It is the feminine, the mother, and the woman who remains to comfort and to provide stability. I became your idealized version of infant eye contact. You desperately wanted contact. But I am getting ahead of myself. My urge to respond, this is it exactly, the need to organize trauma, organize and manage the contents of the unknown. And the photo provides the organization of catastrophe in framing this one captured moment. Time stands still. But I am getting ahead of myself.

Let me speak slower and try to intellectualize my emotional and intellectual moves with a rational heart, but your photos won't let me. Your photos keep the memory present. My reflections of being photographed kept me imprisoned to retain me as a standard of royalty that was difficult and impossible to maintain. But you insisted, and being the generous woman that I am, I gave of myself to let you continue to stare and create an imagined standard. I provided

the necessary feeding schedule of feeding on demand. Standard, I am anything but, but I am your standard of style. My response, my figure in the composition serves as a portal for you to enter my grief vessel, my trauma space.

When I wore my pink blood-soaked dress.

When I wore my black veil as the riderless horse rode by.

As I let my boy's hand go as he saluted his father farewell.

And you saw my decision to see his bare knees. I didn't let him grow up. You did.

But these images of trauma did not come from nowhere. I earned your trust. You loved to look at me when I wore the inaugural gown, and walked you through the White House, as I led the pony, Macaroni, for Caroline to the White House lawn.

Yes, I have been seen and seen. And it all began with a camera. For that is how I met Jack. After college, I worked for the *Washington Times-Herald* as its Inquiring Camera Girl, earning $42.50 a week. I interviewed and photographed individuals with just one question a day. I interviewed Pat and then Vice President Richard Nixon and this is how I met Jack. I was photographing him. I began by composing my future husband, in a composition. I began my relationship with Jack by shooting him.

And you wonder why I hide my eyes with dark glasses, my signature look.

I didn't come here just to reminisce on my accomplishments in grief and styling trauma. I am here to consider transformation from trauma and to release our national images of trauma.

But how do we do this? How do we honor and never forget?

Our nation building is founded on trauma, violence, domination, and death.

Our souvenirs of postcards; sent snapshots of wish-you-were-here at lynchings in town squares across America, drawings and images from the demonstration at Selma to Free Angela, Bobby's last moment.

Please release me from your gaze.

Jesse pointing at the gunman at the motel in Memphis.

Or as I stood next to Lyndon as he is sworn in.

Please release me.

On September 16, 1963, the bombing of the Baptist Church.

And just two months and eight days later my husband . . .

The demonstrations, the riots, the walks on Washington.

At Kent State.

Bobby lay dead.

And Reverend King soon after . . .

Please don't look at me.

I carried the burden of your eyes.

If only I could have lived up to your emotional deliverance.

You kept shooting me but you would have to wait for Princess Di to die by your aim.

I was your target practice. Mary Todd Lincoln—hmm—don't bring her up now—her son died and Patrick, my son, died at three days old. Maybe that was even more painful, carried him and days-old Annabelle, our stillborn daughter.

Sometimes your comparing is my way of coping.

I wore my glasses and slacks with hair back with flats and no socks.

I went to my books.

My poetry.

And my camera.

I restored the White House. But looking back at what happened to me and Jack and our children I feel that this is an awful thing to say: Jackie restored the White House.

As a photographer I understood composition, the image, the first impression. When I restored the White House it was as my obligation not as first lady but in my training as an artist. When I raised money for Grand Central it was with this in mind. It was my training as an artist. My clothes have been on display at the Met, I have edited books, saw my children, my grandchildren, grow. I have accomplished a life on my own and on my own terms outside of the White House.

I look at Michelle and see her—I try and see her for her, not as a vehicle to see her husband, but to see and hear what she is expressing. We look at her arms, bare arms, wrists, and fingers. Many of you look at her arms as a signal of a new style. But our first lady is signaling that it is time to be uncovered, to be exposed, on her own terms, to take the gloves off. I give you my place, Michelle.

My covered, my soaked, my exposed self.

I wouldn't take the dress off. I wouldn't take the dress off. Take me. Let me learn from you.

Let me learn from you. As witness to the woman's

body, and the black female body for viewing—staged, with historical memories of the black female body laid bare, exposed naked for her strength on the auction block. I see your arms. Give me your arms. Lay down your arms.

I will take the dress off.

Let me take the blood-soaked dress off.

I wouldn't show my arms. I wouldn't take it off. Let me learn from you. I am ready for the transformation. Show me the way.

No one photographed my blood-soaked dress when I finally returned home, and took it off in the privacy of my quarters, when the suit was wrapped in tissue by my secretary and sent to my mother.

The paparazzo's stalking and not letting up, the stalking is really the nature of trauma, the never letting up, that lurks in every waking moment. It is the same for Diana.

When you held your camera to hide your face to see my face—my face—I became your face.

And finally with darkened sunglasses on, I became defiant, I became inside your outside. I would not return your gaze, instead dark circles, like a black hole a never-ending eternal night.

Look into my ring of Saturn.

My night of grief.

No morning no dawn no sun.

No sun, for I gave my son to you. After I left my body.
I gave you my son to shoot. He gave you his image
with shirt off and on and smile of Adonis.

Look into him and see that fate has its own way.

A desire you wanted him so.

As he flew into night sky.

And fell into the waters of Martha's Vineyard.

234 Found at the edge of my property.

With wife and sister.

No more to look at.

He exploded, imploded himself.

But was kind enough to do it after I left.

He was so special that way.

I return to you as a mother. I speak to you as a
mother.

When my daughter Caroline embraced Obama I became alive. If she can successfully transfer her need onto him, and Obama will be generous and will take on this role, you have helped my daughter. And Teddy, oh Teddy, he participated too. We wanted to hear from him. He expressed himself to us despite his brain tumor. As if he were living through the emotional head trauma that both his brothers suffered. Teddy expresses his longing, his ache for all of us.

In looking at Jack and me there is the connection with Michelle and Barack. Everyone makes a trajectory to the four of us. But I could not look at Barack Obama, Michelle, his wife, and Malia and Sasha, at first. Why? Because my gaze might frighten them, and veer them off their intended course. I realized that this was the past speaking, this was my own issue. I would be the one who would veer off course. For I was so invested in my ordeal. My trauma. But my grandchildren looked at him. And with their patience I looked. I hadn't looked for so long. My eyes ached. I didn't want to look at first. I looked at Michelle, their daughters. We watched his acceptance speech in Grant Park. While looking at the masses, the skyscrapers, the skyline, I was transported with full knowledge of my Jack winning in Chicago because of Mayor Daley, the democratic machine.

And after Jack died, and Bobby ran in 1968, Bobby planned to travel to Chicago in 68 for the democratic convention but never made it. Death does change schedules.

dignitaries at Love

Record Viewer

236

2 crucify other women w/whom they disagree on a singular issue; it's ironic (& passé)." | **08.31.2010** Presiden

237

The antiwar demonstrators protested in that same park, Grant Park, and I never wanted to go back there with the extreme police violence against our people.

Instead I went to Greece with Onassis. Anything other than the images I knew. It was too painful for me.

And so I return now, I watch Obama, in the same park, Grant Park, for his acceptance speech before thousands, millions, and the space shifts. This shift occurred. I felt the air. I could blink and Caroline could live. And Teddy . . .

Take the emotional deadline and make it a lifeline.

Sometimes I speak to Coretta about this—we watched the inauguration together, through her eyes, through tears at the mall, the Lincoln Memorial, of Martin's dream . . .

We sat near, together, looking out and for Michelle. I couldn't before. Not for Lady Bird or Pat or Betty or Rosalyn or mercy no, not Nancy or even Barbara or Hillary or Laura. I could not look at the festivities— my hope, my hope, our hope . . . But I did. You let me look.

I could not look for whatever reason. My pure idealism. The hope. The promise. Our youth. It was with my attachment to the past that I was able to keep the past present. Those days are over.

end Terry Jones threatens to burn the Koran on the ninth anniversary of 9/11 in protest of the building of t

This time I looked and I looked and I looked with Coretta as Michelle held Lincoln's Bible, as we dressed her daughters, as we accompanied her mother, as she looked at her image, as she put on her shoes, we watched when others weren't watching.

And when she wore gold and when she sparkled and Elizabeth Alexander read her poetry. We looked at her womanhood, her motherhood, her beauty, and her image. We became alive for we wanted to support. Our support gave meaning to our lives and to our husband's lives lost to gain and fulfill meaning. It is sometimes called courage. It is sometimes called faith. But let it remain a mystery of the sum of all parts in the great scheme of life. And that is how I attained some perspective out of the great pain and loss in my life.

This moment, this time, transformed space returned.

And then the dance.

We waited and encircled her.

As she wore her white slender dress and stood as tall as Obama.

Have fun. Have some fun. Have a little champagne and let him hold your waist.

Oh dream.

Oh bliss, oh child of god.

We need to give her this.

We need to give of ourselves.

Release me release me.

Release us.

So I ask you to release me.

From your gaze.

We have suffered enough.

From that day on it will always be before Dallas or after Dallas.

I won't be going to the book depository I am just not that strong.

Now, I know you have written some questions and I will try my best to answer the questions to the best of my ability. You have asked me to speak about Marilyn. Marilyn Monroe and Jack. Jack loved her as a way of loving himself. The part of him that was the pinup. When I looked at her, her voice like a child's— funny but that is said about me too. And Marilyn had the humor, and the style and voluptuousness. What's not to love? And adore?

Before you leave today, walk over to the same spot, the piece of highway.

And drive in the same place where bullets flew. Where crowds gasped.

A nation cried.

When you drive past and over the same spot where I leaned over the car.

My husband killed. His head in my lap. His brain in my hand.

The grassy knoll.

This time don't be locked in your attachment to the national registry of despair.

Don't hold on to me for too long.

Blink.

And keep driving.

And turn on the music.

And give full attention to the present.

Keep your hands steady on the wheel.

Don't cry for me any longer.

Keep your tears in check.

The children need to know.

The struggles, the agony.

The sorrows.

The mysteries.

I'm home.

Oh, Lord.

If it wasn't for art, if it wasn't for art.

Where would my recovery go?

From trauma.

242 I was your art.

Life is more important than art.

But life is meaningless without art.

2

Let's look at the pictures of me together. When I look at a picture of me and remember what I endured all I can say is, "Take a rest, Jackie. With everything you have been through . . . "

The photos of Jackie serve more than historical documentation and representation. Rather the *taking of the photo* becomes an architectural gesture of a platform in meeting others' needs. Whatever way you look at me, the looking accomplishes less for me but rather places my private pain into the public square as an unconscious meeting place. My greatest accomplishment was my intuitive capacity to be the collective embodiment of a public grieving space, a public grieving body that activates the uncertainty of the future, and not feeling safe. The public's and my reaction to Jack's assassination as president was terror, questioning love and protection. Perhaps, our hyperindividualism that came after the early deaths of our leaders is a result of being abandoned. Our narcissism is an expressive response as a way out of this crisis. Certainly I am an icon of style and fashion, so my response to the crisis was to heighten the awareness of self. The documentation of my style guides the nation into an era of extreme individualism—the sixties, seventies,

eighties, nineties, and aughts. But there is another side to this protection of self; there is empathy, even if at times it feels delayed. For it is expressed in the protection of self, the preservation of self.

The photos of my grief and shock underestimate the power of the unseen self that stays inside. Rather than the discourse of compliments that were bestowed upon me in my very *special Jackie way* that I handled grief, I taught a nation to grieve seriously; Jackie *was performing grief and mourning.*

Apparently Mrs. Lincoln was so distraught to the point of being hysterical in expressing her pain that she had to be asked to leave her husband's deathbed. When Jack was shot I refused to take off my blood-stained, pink wool suit. I was continuously asked to take off my suit that day—which I refused. I did not want to leave him, to be taken away, for I was afraid that I would be kept away like Mrs. Lincoln. I did finally wash my face, which I now regret. I wanted the nation to see what they had done to Jack. I am the face of grief.

I now ask the question, how does photography help to differentiate our emotions?

The effects of trauma need to be considered beyond a single event. We need to take into consideration the multigenerational legacies that partake in the shared viewing, the subject, the institution, and the sequences in history that surround the image. Furthermore, the society itself is a personality and needs

to be coaxed into the viewing. The photography of Jackie as subject is in historical context, of historical events and as a public person who functions to separate fact from feeling but instead merges the two simultaneously. What am I getting at? We do not instinctively separate feelings from facts, and when trauma occurs the primitive mind jumps in—fight or flight. The documentary photo, the recording of the *Live Event in Action,* allows a space to merge from the past into the present, view the emotion with time, with results of rest, relief, escape from the illusion of time, space, and the meaning of reality.

How do we experience emotions? In trauma, and recalling trauma, emotions are experienced as a broad range of emotions that are interchangeable. The emotions are undifferentiated. So anger, sadness are felt full blown. What I mean is from my experience the traumatic response can be to overreact, be regressive, or to trigger an outdated emotion than what is called for. The benefit of trauma photography is to regulate the emotional response and to make conscious our reactions. The photograph of trauma gives us a frame to focus, refine our poorly defined emotional resources. Viewing me in mourning provided the skills to process negative emotions and to be certain that they do not become overwhelming and out of place.

The national, rational reaction to trauma creates individual emotional urgency that can be mass emotional panic, an unregulated management of emotion. With each Kennedy disappointment, goals are thwarted, frustration occurs, and instead of adjusting

and seeking change, all of life's predicaments are to be muddled into one big negative emotion. Even the joys of life are not to be appreciated.

That is where the images of me and the Kennedys come in—the images of each of our disappointments, trials and tribulations, sorrows, cruelties, deaths, births, marriages, and heights achieved are made human—that the human is not in control. And in some small way, we feel our smallness in coping with the fragility of life. Because if we don't provide or create a relationship to the human condition we aren't able to distinguish between the muddle of emotions; that is where photographs of my family serve a purpose. When you feel empathy for Jackie and my great burden you are taken off your worry wheel, and place your anger, sadness, nervousness, anxiety, panic into the viewing of me.

Being photographed, being in the relationship of the subject of the photograph allowed me to recover from the difficulty of not being able to distinguish between a current emotional experience from a past emotional memory time. Seeing the images of me, now, it is almost as if the bodily emotional experience can be recalled at any time. But I can leave the trauma in the image. Before understanding this process, this technique, I was at the mercy, a victim of the paparazzi. But once I realized I was the subject/object I rather licensed the focus on me by others and realized this was my service to my country. But as I aged I wore my glasses as a way to protect my inner self from the image of my outer self.

My family, my children, and friends understand that being public means you lose the boundaries between private and public. The immersion between the duality has been known since we are in the womb of our mothers, an experience that all of us share—I become you, you become me, I am your projections. The mirroring, or as in infant mirroring, responding to my emotional expressions, seeking my behavior, searching for my interpersonal relationships, searching for meaning in my clothes, body, and any series of sequences of emotional patterns that would bring resolution, awareness, and disclosure.

With each catastrophe, trauma and crisis, heartache and death that I witnessed, and for the Kennedys (even my second husband Aristotle—both of his children died early tragically), each crisis becomes a surge of energy that becomes all too familiar, but it also creates and startles an emotional immaturity or instability. With each photo taken, with each life event catalogued and dated, the compulsive monitoring and reliving and retelling of my life and image becomes confused from the original intentions of informational value. What is real? What is trauma? It becomes impossible in the present to discern what is real, what is felt from what is now. Luckily, I have been able to manage to feel joy, to feel life, to be present, and not to dwell on others projections and demands of me.

How do the images of me as a closet queen—ha ha ha clotheshorse, fashionista—function with trauma? My shopaholic tendencies or my excessive shopping, wearing, dressing is an impulsive-compulsive behav-

ior. And it is the only allowed form of aggressive and greedy behavior allowed for women. I needed to soothe the loss somehow—and by buying, shopping, and wearing, that is where I became dangerous. I could place the urgency and need in the shopping and acquiring. And that is why the public needed to look at Jackie. The Jackie Look became apparent. The failure to respond is translated in the anxiety in shopping, in the differentiation of the powerlessness. Many of the photos of me expose shock in my face. I was out of my body. Wearing clothes and putting so much attention and emphasis on my body is my feeble and valiant attempt to get back in my body.

At the same time I am focusing on the camera, the shutter is focusing not only on my processing and regulating of negative and horrific emotions but putting and placing these emotions into proportion and perspective for the public as well. This is your doing not mine. Isn't photography healing?

When I do not have clarity, I take out my photos—yes, I have photo albums. My favorite photo memories are with Jack and me out on the boat. Find some photos with . . . our children are with us. And the waves are strong but the sea is calm within its strength. And the sky is so blue. We aren't thinking about the country or politics, but nature, the beauty of nature that is here for all of us. I always make sure to look at the sky, the sea, the waves, the sun, and the moon. The landscape. And for a few moments, the out-of-control feeling that overtakes me is alleviated, and I feel an emotional

DONA ANN MCADAMS

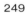

which has been in place since the Deepwater Horizon explosion. | **10.13.2010** After spending sixty-nine days

intensity that is about the human spirit rather than the human body.

Demands were put on me while in my relationship to the seeking of power; the unusual demands of politics, seeking office, the early position of first lady, mother, and wife. The demands made me uncomfortable with my own capacity. I realized that I do not have to respond to every demand, I do not have to pose for every shot. And I learned to separate the feelings from the facts. When I feel terrible it doesn't mean it is terrible. We are no longer living November 22, 1963, today. And the emotions that engulfed me for so long do not have to remain with us any longer. We can remember the tragedies and despair that have happened. But we need to have a sense of proportion to our responses. I would like to invite you to join me in transforming your traumatic emotions and events into emotional knowledge. Let's become wise together . . . hopefully, with the new images of the new era, our nation coming together with purpose, direction.

And the longing of times of reliving trauma through image and text.

Unfinished unfiltered memories of hardship and injustices.

Are not to be forgotten.

Nor am I suggesting that we forge ahead and not look back.

I am simply asking not to be your construction.

Of a monument.

Of grief.

Oh Ancient Peoples.

Shakespeare calls me, and the Greeks whisper in my lair.

How tremendous.

The story, darkness to light, lightness to dark.

Absolve me from your created patterns.

Of varying degrees.

Of tolerance for and deepening of intimacy and autonomy.

No emotional fusion.

But to restore a sense of cohesiveness, cooperation.

And that our reactions aren't based on fight or flight for survival.

Thank you for looking at me. For it was only in you seeing me that I was present. Your looking warmed my heavy heart and nurtured my empty soul.

Your looking protected me from the fear of being forgotten, and sheltered me in the storm of my despair. Somehow, I found my way. I am no longer at the mercy of emotions. And photography guided me every step of the way.

And now some final closing thoughts on Michelle and my daughter Caroline:

I would like to talk about the public's preoccupation with Michelle's bare arms.

I exposed my shoulders at the inauguration. In cold January snow. I wore my shifts, my sundresses. During the Cold War, the Bay of Pigs, there was a public outcry, a transferred distress, a focusing on escape, preoccupied with Jackie's casual dress for church. I showed my knees, arms, and skin.

I don't know what the fuss is really—about a woman's arm. Perhaps at one time it was the throat, the wrist, the cleavage, the ankle, the behind, or sometimes it is even showing too much wit or intelligence—or the tone of the voice. What all of this is about is, it's about a woman's place, a woman knowing her place. Michelle is very clever in having a space/place to allow for the criticism—a woman can't be *too* perfect. But her arms are perfect and a distraction from the larger concerns of today. Instead the subtext is: Who does Michelle think she is?

I think Michelle knows exactly who she is. Is that what makes us uncomfortable? That women can dress

and "Don't Ask, Don't Tell" advocate, re-enlists in the military as an openly gay man following the military

ourselves for our own comfort and display. We can make the decisions of presentation for ourselves.

Interestingly, my daughter Caroline goes sleeveless from time to time. At the Democratic National Convention in Denver she took the stage sleeveless. And even into winter. She is a bit like her father—he went hatless in the winter to the dismay of the hat industry. But I never felt the need to criticize my daughter: "Caroline, you are an attorney, have been on boards, written books, raised a family, buried your mother, father, uncles, and brother, and you go sleeveless— shame on you—you disgraceful woman. Heavens you aren't going sleeveless!"

Instead the public scrutinized Caroline's speech patterns. Her *you knows*. The public does not approve of her speech interruptions. Some people even took the time to count her *you know's* in an interview. It is as if her words are counted like Imelda Marcos's shoes, or that they are as evident as the deficit spending. *You know* is an expression of reaching out to the listener. *You know* meaning we know. *You know* is a valuable mass interruption spoken by an entire generation of baby boomers. And it is a phrase, an utterance that became widespread post-JFK, the late sixties. Caroline's decision to consider political life and running for office becomes demystified with her *you knows*. But her *you knows* have a deeper underlying meaning. This utterance, *you know*, which is associated with an earlier era, a time that defined Caroline. Perhaps she says *you know*, for we do know her, her trauma that informs her service and awareness.

But perhaps we need to listen closer, perhaps she is saying YOU NO.

You, No. You. No. Don't come any closer. Don't take my picture. Don't look at me. Don't come closer. That is why the public pushed her away. She wouldn't be a Kennedy like I was a Kennedy—she wouldn't allow us into the gaze. She won't be her mother. She won't be a Kennedy.

And Michelle.

Michelle shows her arms. Her reach. Her extension. And at her husband's State of the Union speech she wore purple. The two sides coming together. Red and blue. On her torso. The Civil War. Together bringing both sides on her torso. The North and South. But we won't speak about *that*, we will focus on her arms and that she is too casual. When really Michelle Obama is quite formal in her signals and symbols required of a first lady.

254

VIOLET OVERN

hich began in response to a rise in teenage suicides among gay men and women. | **10.25.2010** Lady Gaga's

ACKNOWLEDGMENTS

I am so grateful to the many people and organizations that have supported my creative process and projects that make up the book. I would like to thank my editor Amy Scholder for her guidance and spirit throughout this process.

With appreciation to Elizabeth Koke, Drew Stevens, Jeanann Pannasch, Gloria Jacobs, Laura Tatham, Jennifer Pan, and everyone at the Feminist Press; Chip Duckett and Ron Lasko at SpinCycle; Dona Ann McAdams; Timothy and Karin Greenfield-Sanders; all of the Lizas; Chris Tanner; Lance Cruce; Gary Indiana; David Leslie; Michael Wagner; Becky Hubbert; Randy Martin for his support and for being such a wonderful colleague in the Department of Art and Public Policy, Tisch School of the Arts, NYU; all of my colleagues in performance studies at NYU; The Hemispheric Institute; Richard Scheckner for first publishing "Make Love" in *The Dance Review*; The Day of Community Symposium at Tisch School of the Arts; Bob Holman and The Bowery Poetry Project; Neal Medlyn; Garry Hayes, RIP; Don Guarnieri at The Collective Unconscious; Emerson College; Bob Fleming; Alexander Gray and Associates; Michael Overn; Dare Thompson; Voice and Vision for their support and development of "Impulse to Suck"; Aryana Law; Amy Khoshbin; Darlene Dannenfelser; Melissa Harris at *Aperture*; Dr. Deborah Willis; RLS Inc; and my family, friends, and students.